E.O.Hoppé's Australia

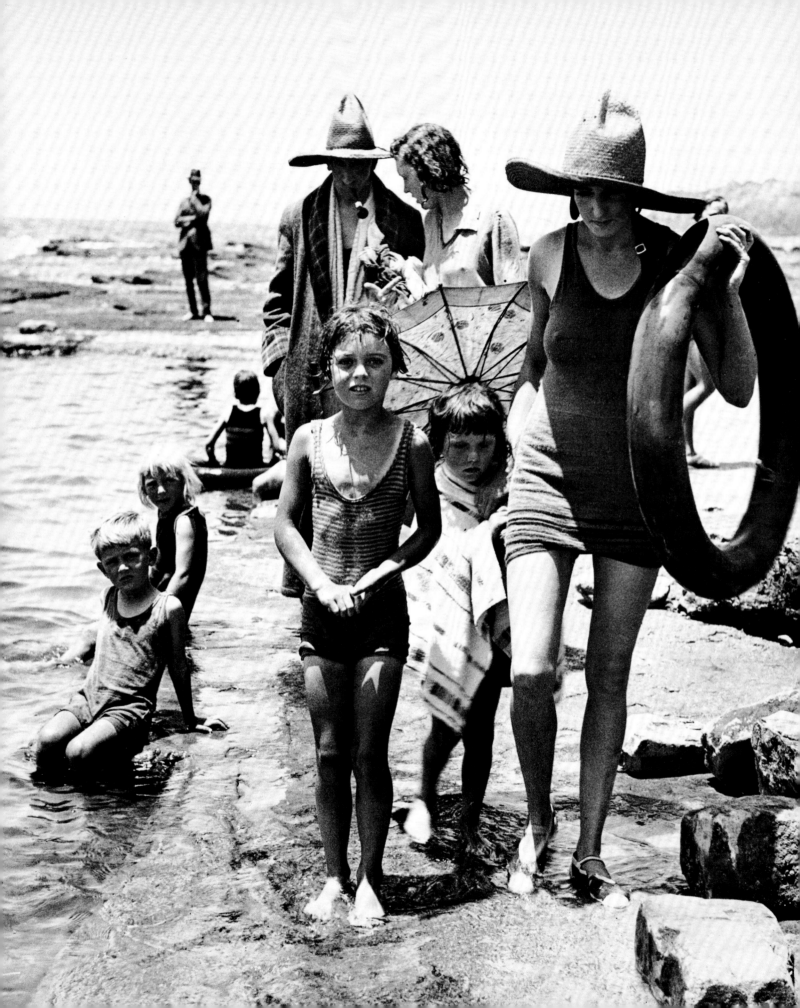

E.O.Hoppé's
Australia

EDITED BY

Graham Howe

ESSAY BY

Erika Esau and Graham Howe

CURATORIAL ASSISTANCE

IN ASSOCIATION WITH

W. W. NORTON & COMPANY

NEW YORK · LONDON

E.O. Hoppé's Australia
Graham Howe and Erika Esau

The text of this book is composed in Centaur
Book design and composition by Katy Homans
Manufacturing by Mondadori Printing, Verona

ISBN 978-0-393-06611-1

W.W. Norton & Company, 500 Fifth Avenue, New York, NY 10110
www.wwnorton.com

W.W. Norton & Company Ltd., Castle House, 75/76 Wells Street, London, W1T 3QT

1 2 3 4 5 6 7 8 9 0

Contents

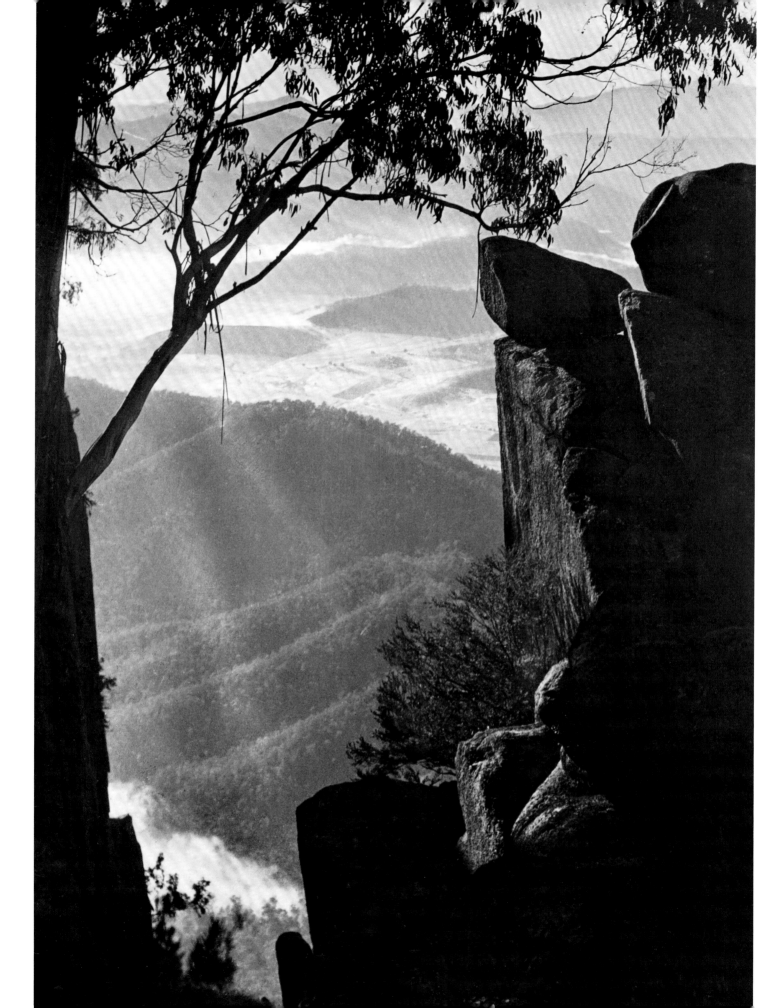

E.O. Hoppé and the Fifth Continent

A PHOTOGRAPHER'S JOURNEY THROUGH AUSTRALIA, 1930

'After the glitter and pageantry of Ceylon and India you will exhaust the pictorial possibilities in six weeks!' This was the remark made to me just before I left England on my expedition to the East by one of the big majority of people who believe Australia to be mostly a country of waterless plains intersected by big sheep-stations with a native population of kangaroos and wild men. How has this mutilated view-point arisen? Is it that Australia has been sacrificed on the altar of sensation, by writers who take one phase of life and work it up into thrilling fiction of the harrowing type? Six weeks! At one end of this period I had concluded that as many months would be inadequate, and so it eventually turned out. For ten months I travelled up and down the Commonwealth with unabated interest, gaining thereby a knowledge which I believe few Australians even can claim to possess. . . .[1]

So begins the text of Emil Otto Hoppé's (1878–1972) photo book of his travels through Australia, *The Fifth Continent* (1931). Hoppé spent ten months in Australia in 1930, from March to December, travelling and photographing everywhere he went. His achievement is all the more amazing in that he carried out his travels at a time when such journeys through Australia required endurance, an intrepid spirit of adventure, and rigorous organisation combined with 'elasticity', as he called it, to take advantage of opportunities as they presented themselves. In 1930, one had to be a bit of a trailblazer to traverse the continent, recording on camera everything that came into view. That he was at the same time able to maintain the rigorous aesthetic standards of photographic work for which he was already famous speaks to the intriguing talent of this remarkable man.

BIOGRAPHY

Hoppé was by nature a restless and energetic spirit. Born into a prosperous German banking family in Munich in 1878, he spent his early years there and in Vienna, where his mother's family originated (he was usually referred to as Austrian, although he called himself a 'cosmopolitan'). His father's business took the family to Paris as well. Hoppé always used the accent on his name, as evidence of his Huguenot origins. Hoppé displayed artistic talent from an early age—a talent encouraged by his mother—but his father was determined that he would enter the banking business. In an unpublished autobiography that Hoppé wrote late in life, he explained that 'my father's bias against bohemianism conflicted with my Austrian mother's appreciation of, and nurtured sense for, beauty'.[2]

In 1900, at the age of 22, unhappy that he could not continue his artistic studies and bored by the prospects of his father's prescribed life for him, Hoppé was on his way to join an uncle in

China to work in an export business when he stopped in London. Enthralled with the city, he decided to stay. His uncle obligingly found him a position there in a bank, where he continued to work for several years, but he almost immediately began efforts to extricate himself from the life of finance.

Two events were particularly decisive in Hoppé's life at this point. First he became involved with London's burgeoning amateur photography circles, most notably through his acquaintance with amateur photographer John Warburg (1867–1931). Warburg encouraged Hoppé to purchase a professional Goerz-Anschütz camera and, most significantly, convinced the frustrated artist in Hoppé that the products of the camera were worthy of artistic consideration. Indeed, the early years of the twentieth century represented the height of popularity for amateur art photography, most particularly the direction of soft-focus studies labelled Pictorialism that sought to make of photography a recognized art. Hoppé began to enter photographic exhibitions and competitions, where he won medals and awards. Here he also came into contact with the many enthusiasts of art photography, including the ambitiously aesthetic adherents of such prominent photographic groups as The Linked Ring.[3] Already displaying his unerring gifts as a showman and energetic self-promoter, Hoppé met everyone of importance in photographic societies and institutions.

In 1903 he joined the Royal Photographic Society, and exhibited with the American expatriate photographer Alvin Langdon Coburn (1882–1966) and other Linked Ring members in 1905. As early as that year, according to his autobiographical notes, he had made portraits of such famous sitters as the Futurist poet F. T. Marinetti, the tenor Enrico Caruso, and the infamous 'Salomé Dancer' Maud Allen. Hoppé's rise to prominence began among these amateur circles of photographers, who talked of photography as an art and shunned the world of business. Hoppé was more ambitious; he intended to make more of his photographic skills than a mere hobby or private pursuit.

The second decisive event in London occurred when he met Marion Bliersbach, the sister of an Austrian financier in the city; they fell in love and were married in 1905. Emboldened by his successes at photographic competitions and encouraged by his wife, Hoppé decided in 1907 to take the plunge and try his hand as a professional photographer. Still dependent on family financial support, he drew up an elaborate 'business plan' and sent Marion—of whom his family, Hoppé later wrote, were enormously fond—to plead his case with his father back in Germany. She was apparently able to convince them that the young man could make a living as a photographer. Emil Otto Hoppé was done with banking forever, and could now dedicate all of his formidable skills to establishing a business in art photography.

Hoppé's entrepreneurial acumen, together with his artistic talent and energetic personality, led his portrait studio to flourish [Figure 1]. By 1913, he was able to move into his own studio in the former house of the pre-Raphaelite painter John Everett Millais (1829–1896)—a combination of luck and business strategy placing Hoppé at a prestigious address that helped attract the most fashionable people to sit for a portrait. The photographer now entered the most stylish society, becoming friends with the likes of George Bernard Shaw, who sat for him many times. By the 1910s, Hoppé had become prominent in the world of art and celebrity, and was particularly favoured by figures in the theater, the arts, and literature. His depictions of the dancers of the *Ballets Russes*,

Figure 1. E. O. Hoppé, *Self-Portrait, London*, 1907

directed by the famous Russian impresario Sergei Diaghilev, were widely published and brought great accolades, so much so that Hoppé referred to this period in his autobiography as 'Renaissance of the Ballet and showmanship par Excellence 1910–1913'.[4]

From the early years of the twentieth century, Hoppé wrote articles in photography journals, expounding on his philosophies of the photographic arts; often these articles included photographs of his lavishly appointed studio. In a 1906 article called 'Individualism', he gave his opinion on the question of the photographer's status as an artist: 'The instrument of the photographer is the camera, but it must be remembered that it is only the instrument, and requires the master mind of the artist to grasp more than the mere realities which nature offers him'.[5] As an indication of the breadth of his fame, this same article was reprinted in 1914 in *The Australasian Photo-Review*, the country's leading exponent of Pictorialist photography.[6] He organised exhibitions of his own work, and participated in international exhibitions as well, most notably in his native Germany. Hoppé was responsible, for example, for working with Sir Benjamin Stone to organise the British contribution to the influential Dresden International Exhibition of Photography in 1909. This exposure and promotion brought in more clients, wanting to sit for their portrait.

By 1919, Hoppé was so sought after as a portrait photographer that he was asked to open a studio in New York City. Though he declined that offer, he did come to the city on his own for two years, from 1919 to 1921. Just as he had done in London, he managed to gain access to the most cultivated circles in New York, and photographed everyone from Anita Loos to Marion Davies, Eugene O'Neill, and Albert Einstein. Hoppé was a forerunner of the 20th-century 'celebrity photographer', as his compelling portrait studies appeared in such stylish magazines as *Vogue* and *Vanity Fair*. Indeed, he was among the first to supply the then-new illustrated magazines with portraits of the leading figures of 'the glorious adult world of art, literature, ballet, and of dazzling society'.[7]

While Hoppé gained his greatest prominence in the Anglo-Saxon world, his German/Austrian background remained important to him. Despite the fact that he became a British citizen in 1912—his command of written English was flawless, although he maintained an Austrian accent all his life—he never severed his ties with the German world. He visited his family there every year, and through their contacts, met everyone of importance on the Continent's cultural scene. For Hoppé, the most important link with German publication occurred in the 1920s, after his return from his first American sojourn, when he was commissioned by the great Berlin publishing firm Wasmuth to produce travel books for their popular *Orbis Terrarum* series.

Germany was at the forefront of photojournalism and illustrated magazines in the 1920s, and the design and printing quality of German photographic travel books rivaled those of any other country. The *Orbis Terrarum* series created an entirely new category of travel book: high-quality productions, comprised mainly of photographs by professional photographers, and geared toward a popular, educated, audience. In many ways they anticipated the photographic 'coffee-table book' of later decades. Wasmuth was particularly renowned for its architecture and art publications, including the famous portfolios done in 1910 by the American architect, Frank Lloyd Wright (1867–1959), that had a profound influence on European architects such as Walter Gropius and Adolf Loos. The publisher's venture into high-quality photographic travel books in the 1920s was a logical expansion of the Wasmuth interest in modern art and architecture.

For this series Hoppé produced a volume on England in 1926, and then was commissioned to do a national photographic survey of the United States that was published in 1927. Hoppé's most ambitious project, the resultant book appeared in both English and German editions: *Romantic America* and *Romantische Amerika* [Figure 2]. As the art historian Phillip Prodger writes about this production, 'conceptually, Hoppé was the first photographer to use a survey approach to distill the American experience'.[8] Hoppé's success with the American project no doubt led to his commission for the Australian volume, once again to be published by Wasmuth, ostensibly as part of the *Orbis Terrarum* series. (It is interesting to note that Wasmuth had listed two volumes on Australia in its original 1924 prospectus for the *Orbis* series.) In 1929 Wasmuth was taken over by the Swiss journalist and publisher Martin Hürlimann (1897–1984), whose Atlantis-Verlag would produce Hoppé's *The Fifth Continent* as a book separate from the *Orbis Terrarum* series.[9]

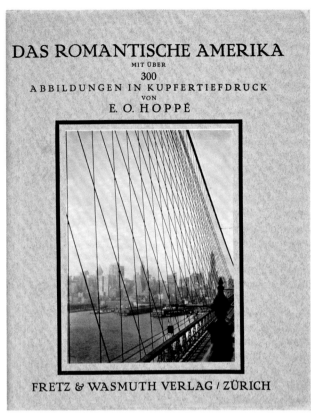

Figure 2. E. O. Hoppé, *Das Romantische Amerika (Romantic America)*, German edition, 1927

PHOTOJOURNALISM

Given Hoppé's cosmopolitan background, it is no surprise that despite his fame as a portraitist, he would eventually get itchy feet. He titled the chapter of his autobiographical notes that covered the 1920s 'Wanderlust.' His decade of travel was also prompted by his many successes in producing photographically illustrated stories in newspapers and journals, both in England and on the Continent. Apparently tired of placating and charming the rich and famous that came to have their portraits made at his exclusive studio, he decided by the end of World War I to take up a new photographic direction, which he always called 'photojournalism'. In his autobiography *One Hundred Thousand Exposures* (1946), he explained that a scoop in 1908 had brought him to journalism: While at the Franco-British Exhibition held at White City outside London that year, he happened to be the only photographer on hand when a hot-air balloon exploded. He sold his exclusive photograph of the disaster to the *Daily Mirror*.[10]

From the time of his return from the studio years in America in 1922, he plunged into the production of illustrated books and 'picture stories' in magazines. Hoppé wrote enthusiastically about the genre: 'There is no end to the possibility of these picture stories. I cannot recall how many features I have sold illustrating a "day in the life" of someone; a hackneyed theme with a perennial appeal to human curiosity, and depending on freshness of conception and ingenuity in treatment to get it across'.[11] His eye for the 'day in the life' kind of story contributed directly to many of the images he produced while in Australia.

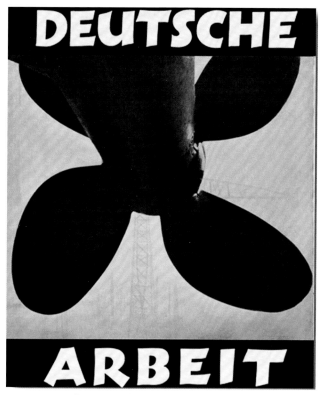

Figure 3. E. O. Hoppé, *Deutsche Arbeit*, 1930

ART AND INFLUENCE

As Hoppé was leaving London for Australia late in 1929, his seminal photo book on the German industrial build-up of the late 1920s, titled *Deutsche Arbeit (German Work)*, was being printed by the German publishing house Ullstein.[12] While his previous books on the United States and England had been more scenic and journalistic, with his German work Hoppé whole-heartedly embraced industrial architecture as a vehicle for modernist photographic expression [Figure 3].

In the mid-to late 1910s the idea of making abstract photographs of 'commonplace' objects became important in photographic art. This approach was pioneered particularly by Americans, including Paul Strand (1890–1976), Edward Steichen (1879–1973), and Alfred Stieglitz (1864–1946), and in England by Alvin Langdon Coburn and Hoppé, among others, who exhibited abstract photographs as art.[13] By the early 1920s these and other ideas of modernism were adopted by artists in many countries.

The photographer Albert Renger-Patzsch (1897–1966) was among the pioneers of the new style in Germany. His time in the United States paralleled Hoppé's for a period; in the mid-1920s, while Hoppé was making his photographic odyssey across America, Renger-Patzsch worked as a photojournalist for the *Chicago Tribune* newspaper. On returning to Germany in 1928, Renger-Patzsch published his landmark photo book *The World is Beautiful (Die Welt ist schön)*. It represented new thinking in modernist aesthetics and sparked a movement that became known as New Objectivity *(Neue Sachlichkeit)*, in which subjects are presented in a direct, almost clinical style in contrast to the emotionally charged ideas of Pictorialism. Hoppé, who had begun his work in the Pictorial

style in the first decade of the twentieth century, employed similar strategies as he evolved into a leading modernist.

In the early 1920s Hoppé had discovered industrial machines and architecture as a subject of pure geometric form for photographic abstraction. He was not so interested in what a piece of industrial architecture was or did so much as in the visual possibilities its dynamic shape and form provided. He would regularly visit ship construction sites, steel foundries, or any kind of heavy industry. There he found pleasing shapes in the ship hulls, exquisite geometric construction in the framework of gantry cranes, and brave new forms in billowing smokestacks [Figures 4–7].

Indeed, throughout the decade, as he traveled the United States and England, Hoppé continued the development of his industrial, more modernist style. Upon his arrival in Australia in 1930, he had reached a point where he was ready to integrate all the elements of his previous work, bringing together his Pictorialist beginnings, his portraiture and interest in typologies, and his most recent industrial, modernist work. As a new kind of subject for art photography, Hoppé's images of industrial abstraction, and indeed, his many other subjects as well, would have been of great interest to Australian photographers as he was already well-known in photographic circles.

Hoppé's arrival in Sydney was publicised in a short article in the *Sydney Morning Herald*, where he was described as a 'Noted Traveller'.[14] He had been able to organise an exhibition of his previous works at David Jones's main store gallery. This event introduced him to Charles Lloyd-Jones (1878–1958), the owner of the department store and a prominent patron of the arts in the city. He and Lloyd-Jones apparently had great rapport: Hoppé thanked him for his hospitality in the introduction to *The Fifth Continent.*

Hoppé had shipped three cases of photographs from London to be shown in Australia. One case containing his portraits was lost en route, and did not arrive in time for the exhibition, which opened on 2 April 1930. The review of the show in *The Australasian Photo-Review* notes that the exhibition, consisting of seventy-nine photographs, was opened by Sir Hugh Poynter, son of the great English Academy painter Edward Poynter (1836–1919), with a distinguished audience including Lady de Chair, wife of the governor of New South Wales.[15]

The unnamed *Australasian Photo-Review* reviewer praised the exhibited works, which were divided into three sections. 'Romantic America', which displayed prints from his work made in the United States; 'Continental Memories', which presented Hoppé's views of European cities and landscape; and 'The Romance of Steel and Cement', a group of seventeen examples selected from his industrial studies. The reviewer lauded these as '. . . work at once so striking in presentation and modern in outlook'.[16]

The critic also stressed the importance of Hoppé's use of enlargements—a technique still unusual in Australia at that time. 'Big prints are in accord with the spirit of the times', the review continued; 'they are close-up, vigorous, dynamic—so it is natural that he should take full advantage of enlarging and present his work on that scale which it merited'.[17] According to another review, in a cultural newspaper called *The Australian Budget* (complete with a caricature of a dapper-looking Hoppé [Figure 8.], 'the pictures Mr. Hoppé has on exhibition may be bought by those who desire the highest expression of camera art'.[18]

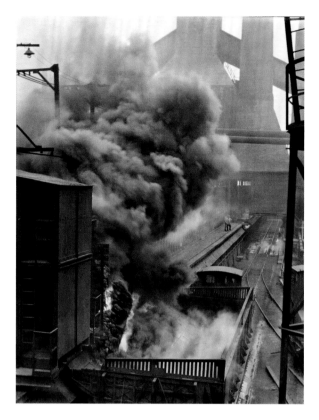

Figures 4–7. E. O. Hoppé, Photographs from *Deutsche Arbeit* at the David Jones department store exhibition, 1930

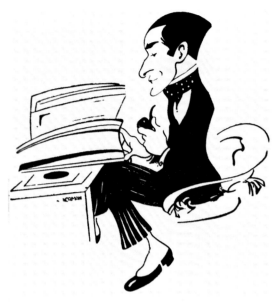

Figure 8. Caricature of E. O. Hoppé, *The Australian Budget*, 1930

Hoppé's own notes from the opening show that it was also attended by poet Dorothea Mackellar (1885–1968) and Australian art publisher Sydney Ure Smith (1887–1949), who both purchased Hoppé's photographs.

An invitation to the exhibition found in the personal papers of Harold Cazneaux (1878–1953), one of the founders of the Sydney Camera Circle and one of Sydney's most renowned modern photographers, suggests that Hoppé had seen to it that members of the city's photographic and artistic circles were aware of his exhibition.[19] They no doubt attended sometime during its two-week run, although no documents have been found to indicate who may have seen it. As Gael Newton, the senior curator of photography at the National Gallery of Australia, points out, the photographic world in Sydney at that time was small enough, and the opportunity to see a one-man photo exhibition by a famous European photographer was so unusual, that most of the arts community would have known about it and would have wanted to see it.[20]

At the time of Hoppé's arrival in Sydney, Cazneaux was also turning away from his hallmark Pictorialist genre studies of Sydney life towards a more modern sensibility. He had been photographing the construction of the Sydney Harbour Bridge from as early as 1926, but by August 1930, likely after he saw Hoppé's industrial imagery, he confirmed his new style by making several triumphant and dramatically modern images of the bridge's joining arcs. These were published by his friend, Ure Smith, in *The Bridge Book* [Figure 9]. One year later, upon the bridge's completion, Ure Smith published a commemorative sequel, *The Second Bridge Book*, this time including Hoppé's photographs of the Sydney Harbour Bridge alongside those by Cazneaux.[21]

In 1934 and 1935, during Cazneaux's commission for Broken Hill Propriety (B.H.P.) to photograph the mining industry, he adopted a hybrid style combining visual cues from both the Pictorialist and Modernist camps [Figure 10]. Hoppé had also combined styles, as in his some of his industrial photographs in *Romantic America* and *Deutsche Arbeit*.

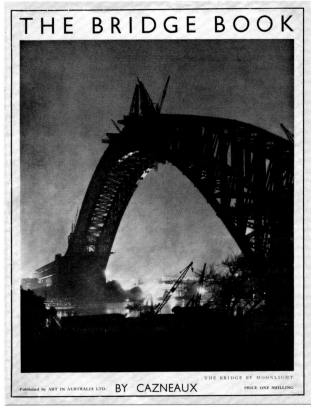
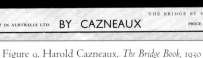
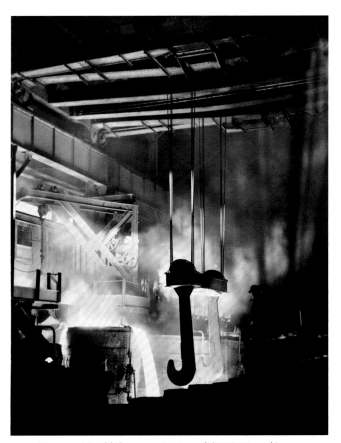

Figure 9. Harold Cazneaux, *The Bridge Book*, 1930

Figure 10. Harold Cazneaux, *Pouring steel (B.H.P. Newcastle)*, 1934

 In turn, Cazneaux may also have inspired Hoppé. In 1929 Cazneaux's thoroughly modern view of Bondi Beach bathers, seen from above, shows their bodies in the sand as a clear abstraction of form [Figure 11]. Hoppé's image the following year is made from a similar elevated view [page 84], and expresses a similar formal idea of compositional order within apparent visual chaos.

 Another photographer, German-born Wolfgang Sievers (b. 1913) had seen *The Fifth Continent* (published in German as *Der fünfte Kontinent*), and was likely to have seen other books and articles Hoppé had published in Germany as well. In 1939, Sievers emigrated to Australia, where he went on to become one of the country's best-known industrial photographers. (As it happened, his emigration was aided in part by fees earned from the sale of his Portuguese photographs through Hoppé's photo agency, Dorian Leigh.) Sievers' 1933 photograph of factories in the Ruhr valley, for example, exhibits stylistic similarities to some of Hoppé's industrial images in *Deutsche Arbeit*.

 Another friend of Ure Smith who likely took an interest in Hoppé's photographs was the Australian photo-modernist Max Dupain (1911–1992), who in 1930 was a first-year apprentice to Sydney photographer, Cecil Bostock (1884–1939). David Moore (1927–2003), Max Dupain's apprentice from 1948 until 1951 who went on to become one of Australia's most important photo-journalists, by coincidence acquired several Hoppé photographs in his collection.[23] While we may never know the true connections between Hoppé and each of these Australian photographers, it is

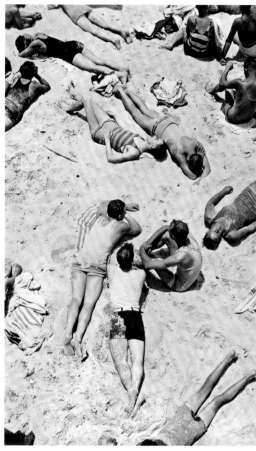

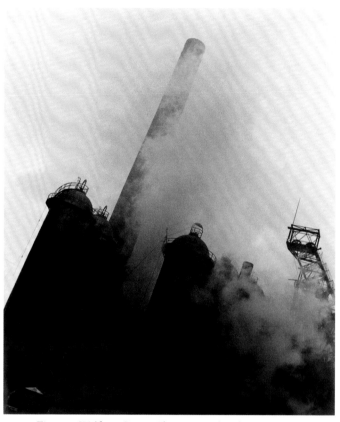

Figure 11. Harold Cazneaux, *Beach Scene*, 1929 Figure 12. Wolfgang Sievers, *Blast furnace in the Ruhr, Germany*, 1933

notable that Cazneaux, Sievers, Dupain, and Moore all excelled at industrial photography and count that work among their best.

HOPPÉ'S TRAVELS IN AUSTRALIA

The precise nature of Hoppé's commission is difficult to define with certainty now. He did have a contract with Wasmuth, signed in May 1929, to produce the Australian volume, which Atlantis-Verlag eventually published as *Der fünfte Kontinent* after the firm took over Wasmuth's contracts.[24] When interviewed in 1994, Hoppé's son Frank said that the entire trip was sponsored by various government tourist agencies. In his autobiographical notes, Hoppé mentioned a commission from the German publishers Ullstein to travel to Asia and Australia; but in his autobiography, *One Hundred Thousand Exposures* (1946), he wrote, 'I received an offer to create a book . . . for the Commonwealth of Australia and also to provide material for a steamship company . . . on this occasion my professional work started from the time I boarded the boat train since photographs had to be taken covering the whole technique of tourist travel'.[25] That he was sponsored at least in part by the Australian tourist offices seems likely, since he had itineraries devised for him in every Australian state, and his arrival in each location received considerable press coverage. Once in Australia, he also sometimes travelled with the director of the newly formed national tourist association. Hoppé

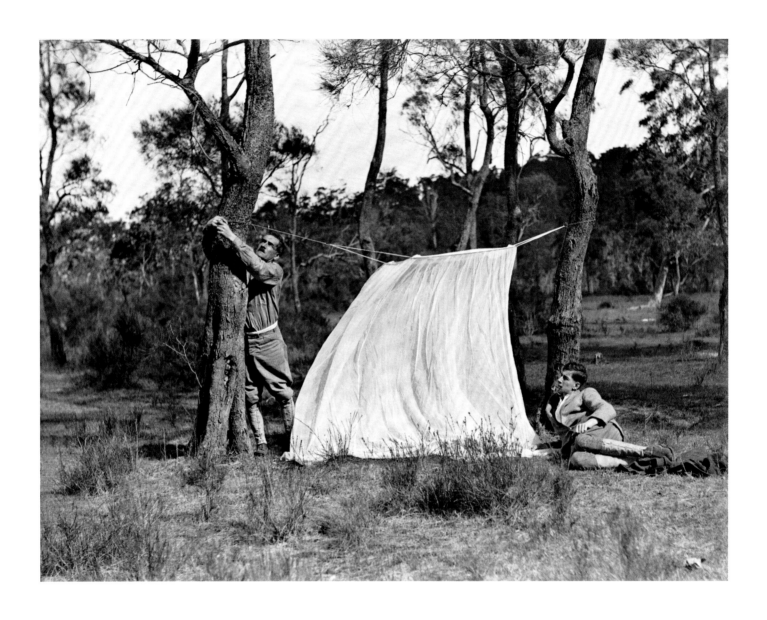

Figure 13. E. O. Hoppé, Emil and Frank Hoppé attempting to erect a tent in Arcadian New South Wales, 1930

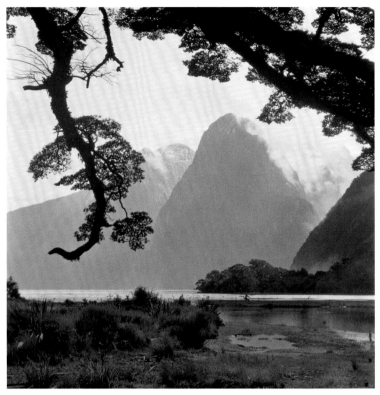

Figure 14. E. O. Hoppé, *Milford Sound, New Zealand*, 1930

did produce numerous articles based on his discoveries in Australia for Ullstein magazines, such as *Berliner Illustrirte Zeitung*, throughout the 1930s.

Hoppé arranged introductions with influential people well before the trip, and researched the areas he was to visit in depth. In *One Hundred Thousand Exposures*, which he filled with helpful hints for fellow photographers, he explained, 'As usual, I was fortunate in securing valuable introductions, both to private individuals and Government officials, thus saving myself much waste of time. I mention this point again, because prospective travellers with a camera are strongly urged not to neglect making the best possible use of introductions when planning a tour'.[26] His notebooks of negatives—kept throughout his career and still largely intact—indicate as well that he took formal portraits along the way, including many of Indian aristocracy and members of Australian polite society.

Accompanied by his 18-year-old son Frank—who served as his secretary, camera hauler, and occasional assistant photographer through most of the trip [Figure 13]—in September 1929, Hoppé departed for Ceylon, India, New Zealand, Australia, and Indonesia, travelling out on the *Otranto*, of the Orient Line.[27] They first arrived in Ceylon, then continued up through southern and northern India, staying with rajahs and other potentates along the way. They sailed from Colombo on the *Orvieto*, landing first in Perth/Fremantle on 21 January 1930, where Hoppé was interviewed for the Perth *Daily News*. This same ship arrived in Melbourne on 27 January, at which point the Melbourne papers interviewed him, and announced Hoppé's intention to travel throughout Australia.[28]

Frank says that they went from Melbourne directly on to New Zealand, where they travelled and photographed until the middle of March. They were both immensely impressed with the islands, and particularly proud that they had endured their trek to Milford Sound, which at that time still required a rugged backpacking expedition to visit [Figure 14]. Conditions before the era of mass tourism were admirably 'primitive' and unspoiled, in Frank's words. Many years later, Hoppé would write at length about the experience and the majesty of this landscape; in his autobiography he described the Sound as a 'natural setting for Wagnerian Opera'.[29] An article in a New Zealand newspaper entitled 'World Wanderer/Famed Photographer Tours/Marvellous Milford Sound' announced Hoppé's departure for Sydney on 21 March, 1930. He sailed on the *Ulimaroa*,[30] where he discovered on board a travelling circus troupe, the members of which offered him an unexpected opportunity to photograph interesting 'types', to be included, he wrote, in his hoped-for volume on 'The Australian Character' [Figures 15–18].

The first mention of Hoppé in the Sydney press occurred on 28 March 1930, shortly after he docked in Woolloomooloo. He began photographing the city from the moment he arrived. Progress on the construction of the Sydney Harbour Bridge serves as a convenient marker of his time in the city, for its presence immediately and understandably caught Hoppé's photographic eye. His first images of the construction site show the bridge with unfinished spans on both sides, as it appeared in March of that year. Given Hoppé's penchant for scenes of industry and construction and the tremendous fanfare accompanying Sydney's engineering wonder, it is no surprise that he produced an entire series of shots focussing on the bridge's construction. His letters of introduction allowed him to gain access to the site, climbing its new edges along with the workers, and creating abstracted images of its enormous cables [pages 48, 49]. Hoppé even took formal portraits of the bridge's engineers, Ralph Freeman [Figure 19] and John Bradfield [Figure 20]. His camera again turned to the structure later in the year, on the day when the two spans were ceremoniously joined, 21 August 1930. Between these dates, Hoppé had travelled across the continent several times.

The review of Hoppé's Sydney exhibition in the *Australian Budget* provides information about his itinerary: 'He leaves after Easter for Melbourne, Adelaide, and Perth. He will make Alice Springs his center for his Central Australian campaign, and hopes there to be able to get studies of the "Stone Age Man" at his very best. Then he will conclude his tour in Queensland, and on the Great Barrier Reef'.[31] Throughout April, Hoppé photographed in Sydney, making day trips to the Blue Mountains, Jenolan Caves, up to Moree, and on to the city beaches. He was particularly enthusiastic about the opportunities to photograph people, signs, and scenes at the Royal Agricultural Show (The Royal Easter Show, as Sydneysiders still call it), and he also photographed the crowds at the Easter Monday Races at Randwick. Hoppé was in his element at these events, producing a delightful series of images filled with narrative detail, along with many character studies [Figures 21, 22].

Right before leaving Sydney for the south, he also gave a talk on 2BL, the Australian Broadcasting Company's radio station; the topic was 'What IS Photography?' No doubt a main focus of conversation on the radio would have been Hoppé's putative expertise as a judge of feminine beauty, a status he had attained by publishing *The Book of Fair Women* (1922). While the photographer had

Figures 15–18. E. O. Hoppé, The Lias Circus Troupe: TL: George Anderson, Director; TR: Mrs Ilba,
The Strong Lady; LL: Mr Newman, Bandleader; LR: Mr Moody, Elephant Trainer, 1930

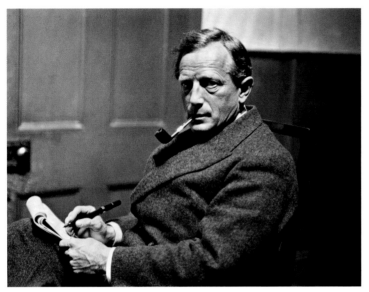

Figure 19. E. O. Hoppé, Ralph Freeman, 1930

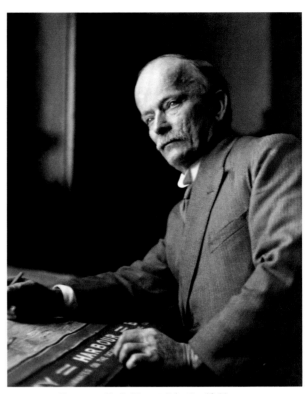

Figure 20. E. O. Hoppé, John Bradfield, 1930

considered it an extension of his interest in character types, the entire exercise devolved throughout the 1920s into articles on competitive rankings by overzealous reporters in each country Hoppé visited. The Australian journalists were no exceptions: the announcement of his ABC radio talk emphasized that Hoppé 'has photographed the feminine beauty of every country, and during his sojourn in Australia he has taken the portraits of many beautiful Australian women, which he will exhibit on his return to England in the special Exhibition he is giving in London of his photographs taken in Australia'.[32]

Hoppé's next journey was a drive down the Princes Highway, with a stop at Marlo Inlet near Wilson's Promontory, and, ever on the lookout for opportunities to photograph industrial machinery, the State Electricity Works at Yallourn, Victoria. At this point, according to his son's recollections, Frank no longer accompanied his father.[33]

After spending some time photographing in Melbourne, Hoppé took the boat to Launceston, Tasmania, where he was lionised as 'World Traveller and Artist'.[34] A reproduction of his portrait of Thomas Hardy appeared with one of the articles. Once again, Hoppé charmed the journalists by praising the Australian landscape and commenting on Australian 'flowers more beautiful than our own'.[35] He was in Tasmania in the first weeks of May, taking pictures not only of scenery and cityscapes, but also of the great dams and hydroelectric projects at Miena and Waddamana. He was also quite taken with scenes of the apple industry, making a series of photographs of people working in the apple-packing plants, and some good studies of Tasmanian farmers[Figures 23, 24]. About 18 May, Hoppé was in Adelaide, where he photographed in and around the city and also in

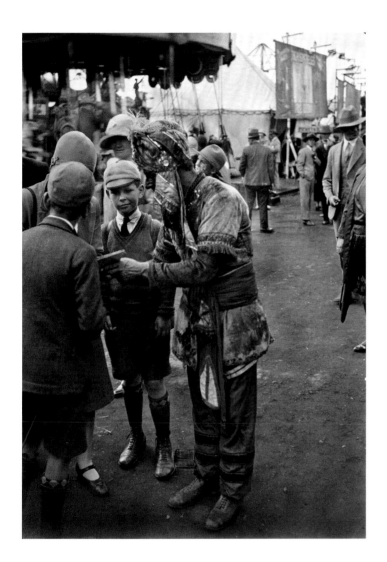
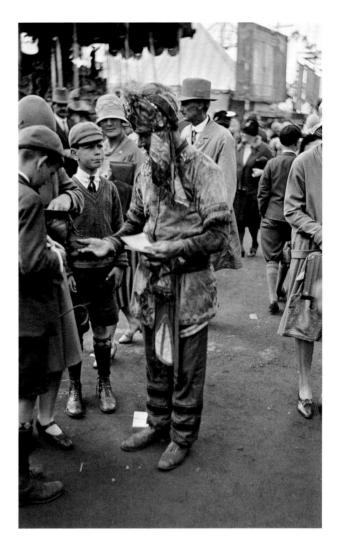

Figures 21, 22. E. O. Hoppé, Fortune Teller, The Royal Agricultural Show, Sydney, 1930

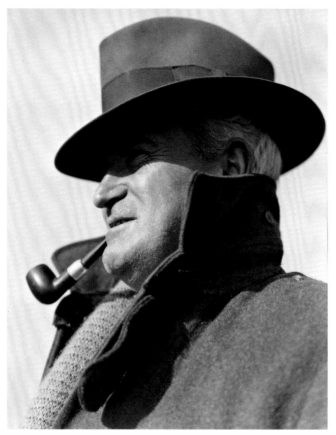

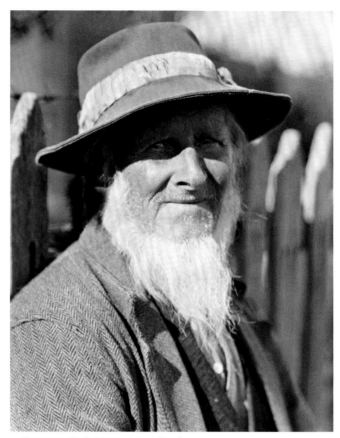

Figure 23. E. O. Hoppé, Mr Fulton, sheep farmer, Tasmania, 1930 Figure 24. E. O. Hoppé, W. H. Beecher, Fruit-grower, Tasmania, 1930

the Lofty Ranges. He then headed out by train to the north, stopping at the railhead nearest to the underground opal-mining town of Coober Pedy [Figures 25, 26]. As he told the *Sydney Morning Herald* at the very end of his Australian journey, from the railhead he journeyed to Coober Pedy—some eighty miles away—by truck [Figure 26]. After spending interesting days with the miners—he was particularly taken with the story of Minnie Barrington, a young Englishwoman and the only woman in the settlement [see Figure 37]—he rode to Oodnadatta on the back of a camel, and then on by train to Alice Springs.[36]

Hoppé was in Alice Springs with the telegraph operator at the Overland Telegraph Line office on the night that the pioneering aviatrix Amy Johnson (1903–1941) arrived in Darwin at the end of her historic solo flight from England to Australia. She landed on 24 May 1930. A clipping mentions that Hoppé passed through Kalgoorlie on 29 May, and was in Perth the next day. He made a subsequent trip to Kalgoorlie, where he took many photographs of the old mining town, and wrote with amusement about the town's 'Yankee' mayor, Ben Leslie [Figure 27].

Hoppé travelled to the south of Western Australia, where he made a memorable trip to the Kauri forest timber camps in Pemberton and Bunbury, meeting and photographing 'true Australian characters' in the bullockies and rugged lumbermen. Here he met and photographed another of his favourite women, Annie Brown [page 156], a particularly endearing wife of a lumberman and mother of fourteen. He also wrote insightfully and with some dismay about the destruction of

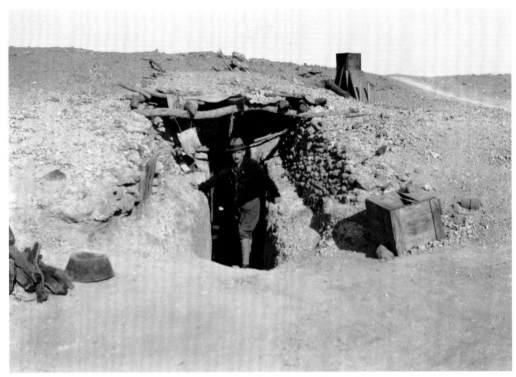

Figure 25. E. O. Hoppé, In the Dugout, Coober Pedy, 1930

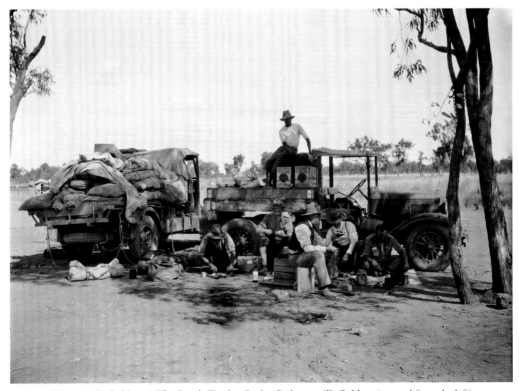

Figure 26. E. O. Hoppé, The Supply Trucks, Coober Pedy, 1930 (E. O. Hoppé second from the left)

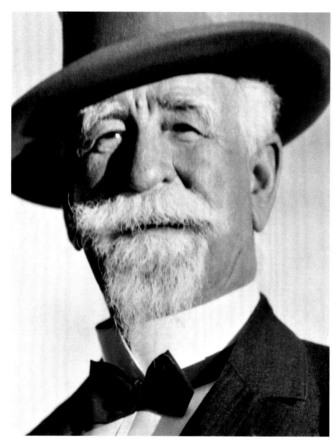

Figure 27. E. O. Hoppé, Ben Leslie, Mayor of Kalgoorlie, 1930

old-growth forests, lamenting that trees in Bunbury were seen not as significant living things but merely as timber.[37] Also out of Perth to the north, Hoppé visited New Norcia, where he was astonished to find a Spanish Catholic monastery and school. There he made one of his most thoughtful photo-essays, with accompanying text [pages 165, 166, 169]. He was back in Sydney by May, where he made formal portraits of Sir Hugh Poynter and, on 26 June 1930, a series of extraordinarily penetrating studies of Dorothea Mackellar [Figure 28].

In several of his writings, including *One Hundred Thousand Exposures,* Hoppé implies that he took the train from Brisbane to Fremantle; he may instead have journeyed at the end of June from Sydney to Brisbane by boat, then travelled all the way across the continent again on the train. At this point he probably made his memorable and arduous journey to Hermannsburg, the German Lutheran mission in the remotest region of the Northern Territory [pages 162, 164, 167, 168], and visited an Afghan camel station in the Outback [pages 134, 135]. If he went as far as Perth in July, then he may have at this time made his visit to New Norcia, as well as to the Western Australian timber camps in those weeks. In any case, Hoppé had to have been constantly on the move to cover such enormous ground in such a short period. His family said that he always walked at a staggeringly rapid pace; he must have been at times quite frenetic in his photographing, pushing himself constantly to get to the next interesting place.

In Darwin, he met and wrote about the Northern Territory constabularies, as well as local

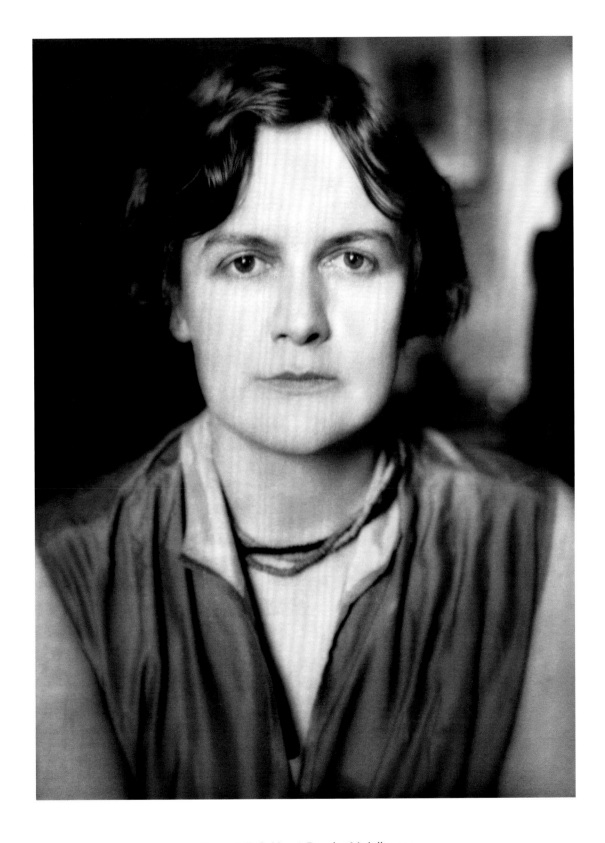

Figure 28. E. O. Hoppé, Dorothea Mackellar, 1930

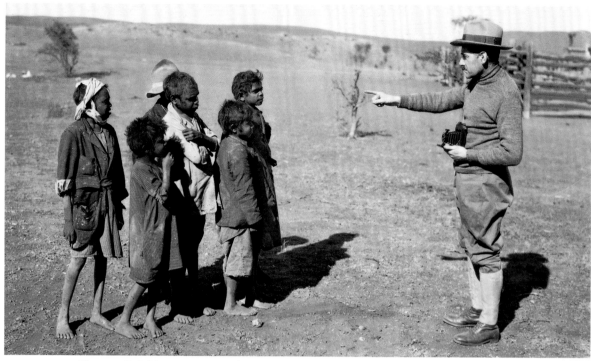

Figure 29. E. O. Hoppé at Hermannsburg Mission directing Aboriginal boys for their photograph, 1930

authorities on the Aborigines. These contacts were indispensable in gaining Hoppé access to Aboriginal communities, where he photographed detailed studies of Aboriginal ceremonies and dance [Figure 29]. These studies were reproduced repeatedly in European magazines. In most cases, Hoppé included them in his own articles written for 1930s German publications such as *Atlantis*, *Berliner Illustrirte Zeitung*, and *Zürcher Zeitung*. Later, in the 1950s, these same images were used in articles written by others, selected from the files of photographic agencies with whom Hoppé worked. European fascination with other ethnic groups in Australian life prompted Hoppé's studies of the Chinese community in Darwin, photographs that also appeared in German magazines as photo essays [Figure 30; pages 192, 193].

From Darwin, Hoppé may have flown or sailed to Thursday Island, at the tip of Queensland's Cape York Peninsula, where he went out on the boats with the pearl fishermen. Such opportunities to film 'the exotic'—the Japanese and Aboriginal fishermen—appealed to the journalist in Hoppé. It is interesting to note that at this point, Hoppé was usually referred to in newspaper articles as a journalist first, with only passing reference to his status as a photographer. From Thursday Island, he may have continued by ship to Queensland and the Great Barrier Reef. In another section of his autobiographical notes, however, entitled 'An adventurous train journey through the Dead Heart: Alice Springs to Darwin', he wrote of camping at Barrow Creek, Northern Territory, where he was kept awake by the radio announcing the cricket Test Match scores all night. This spot is probably close to the place where he found and photographed an old automobile with a sign attached to the back announcing the cricket scores: 'Woodfull 54/Ponsford 110/Bradman 232'—a

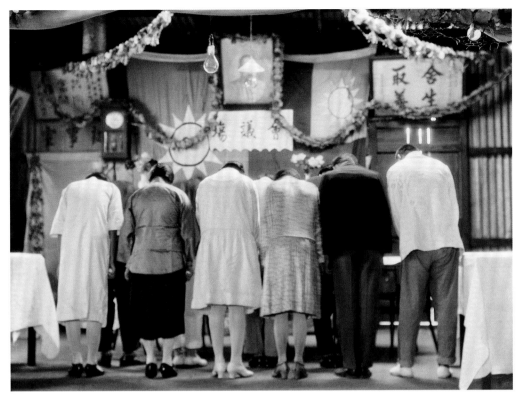

Figure 30. E. O. Hoppé, Headquarters of the Chinese National Party, Kuo Min Tang, Darwin, Northern Territory, 1930

score that would indicate one of the Test Matches played at the beginning of July 1930 [page 144]. From here, Hoppé later wrote, he 'took the plane from Daly Waters to Barkly Tablelands into . . . Camooweal', on the Queensland Northern Territory border.

No matter which direction he came from, he was in Cairns, Queensland, on 22 July 1930, when a newspaper reported, 'Mr. Hoppe has been in all the Australian States and arrived in Cairns on Sunday night after a trip across Australia to the Northern Territory and Arnhem Land. He commenced that trip at Kingoonya on the Trans-Continental line and travelled 190 miles to the opal fields at Coober Pedy about 60 miles south-west of Oodnadatta'.[38] He explored the Great Barrier Reef and its islands, marvelling at its pristine beauty. 'I should think that a stretch of the Queensland coast, in and around Townsville, might easily become a second Riviera', he later told a reporter in Sydney.[39]

Hoppé's island visits in Queensland included a trip to the notorious Palm Island community, where he depicted Aboriginal ceremonies and tribespeople, though he was apparently unaware of or oblivious to their virtual imprisonment on the island and the sad story that was unfolding there [pages 198, 199, 201]. In other places, such as his descriptions of the Aborigines of Central Australia, his opinions about the indigenous people's plight reveal an uninformed if predictably European romanticism, in which the tribesman was painted as a 'noble savage' who thrived if allowed to live a traditional life in the bush, while those in the missions were degraded and incapable of betterment. At the same time, his images of traditional rituals portray a stunning array of tribal customs, and are among the most powerful photographs he took in Australia. His depictions of

Aboriginal life were among his most sought-after offerings to European publishers in the 1930s,[40] and one of his Palm Island studies became the cover image for *Der fünfte Kontinent* [Figure 31].

Along the Queensland coast, Hoppé travelled by the ship *Malabar*, arriving unannounced at the offices of the *Johnstone River Advocate* in Innisfail a few days after his stop in Cairns.[41] The paper's reporter described Hoppé's purpose in stopping there: 'Innisfail was not included in the itinerary prepared for him by the Queensland officials, so he included its name in the list himself. "I wanted to see Australia's greatest sugar-producing centre for myself. . .".[42] He continued his interest in documenting Australia's ethnic diversity in the Italian communities of Roma and Ingham, while in Townsville, Hoppé recorded an amusing German name on a shop sign: 'Ohnesorgen', meaning 'No Worries', set against the background of a near-tropical landscape [page 186].

By August, Hoppé was back in Sydney, photographing the joining of the two spans of the Sydney Harbour Bridge [Figure 32]. Another article about the bathing beauties of Bondi appeared in the *Sun* out of Melbourne on 28 August, but these photographs were probably taken by Hoppé earlier in the year [pages 87–89]. The fact that they appeared in an Australian newspaper while Hoppé was still in the country does demonstrate that he was developing his film locally rather than shipping it back to London for later processing. In that same month, he made trips to Canberra, the Snowy Mountains (which were appropriately snow-covered), and other parts of rural New South Wales.

His views of the newly constructed capital are particularly amusing, as his ironist's eye captured the disjunction between the elegance of a few grand buildings such as the Parliament House

Figure 32. E. O. Hoppé, Joining of the two arcs, the Sydney Harbour Bridge, from the Domain, 1930

and the Civic Buildings, standing in isolated splendor alongside a few paved roads amidst the Australian bush. Indeed, his images of the Kingston shopping centre and a few substantial houses then going up around Red Hill give a truthful picture of the early days of the city, when it was nothing more than an overly ambitious country town. As Hoppé himself later wrote in an article titled 'Built to Order', the capital was '. . . like a finely cut gem, whose heart lacks fire, having yet no background of human experience to give it atmosphere [page 92]'.[43]

In Hoppé's later photographs of the trip it seems that the Australian land and the Australians' world-view had begun to loosen him up, if ever so slightly. In his attempts to capture the essence of Australia, his camera's choices became less consciously composed, more relaxed. Hoppé also noticed that in the time he was in the country, the effects of the Depression were becoming increasingly pronounced: along with a photo-essay of a working woman's life in Sydney, he also produced a series of images of the unemployed, a number which appeared to have grown substantially from March to August [pages 73, 74].

The last article in an Australian newspaper about Hoppé's journeys appeared in the *Sydney Morning Herald* on 15 September 1930, announcing his departure. Frank stayed on in Sydney with his 'half-time' job at David Jones while his father toured for several weeks in Java and Bali. Entries in his negative log books show Hoppé returning to Sydney in November or December and that he was back in London by late January, 1931.

Hoppé must have begun work on *The Fifth Continent* as soon as he returned to England. In January 1931, correspondence between Atlantis publisher Martin Hürlimann and Hoppé indicates that the publishing house had agreed to take over the Wasmuth contract for the Australian book. The book bears the imprint 1931 in both the English edition, published by Simpkin Marshall Ltd., and the German edition, published by Atlantis-Verlag. Hoppé dated the foreword as July 1931.

Hoppé made more than 3,300 photographs during the Australian trip, yet in the end, only 160 images were reproduced in the book. The images chosen for the book do not represent the most striking or artistic impressions that he made in Australia. They instead seem to reflect the publishers' desire for a marketable travelogue rather than Hoppé's expressed hope to create a picture of the Australian character. German art historian Roland Jaeger, an expert on the *Orbis Terrarum* series of photo books, points out that it is likely that Hürlimann himself selected the images that made the final cut into the Australian volume.[44] Hoppé must have been disappointed that more images from his archive were not included, but he was no doubt responsible for the dust jacket image, a photomontage of the photographer straddling the globe and pointing his camera at the Southern Hemisphere [Figure 33]. In later writings, when he listed those projects he wished to complete, he always mentioned that he wanted to do another volume on 'The Australian,' focussing entirely on photographs that captured the essence of the Australian psyche.

Both the critical and popular receptions of *The Fifth Continent*, whether in Europe or Australia, are hard to determine. One review appeared in *The Geographical Journal* of the Royal Geographical Society in 1933.[45] The reviewer considered the 'picture-book' 'an uncommonly beautiful production', saying that the pictures 'reflect Mr. Hoppé's delight in Australian life'.[46] The reviewer did recognize that 'although this volume of reproductions contains no more than the pick of his material, it must be one of the most representative collections of Australian views ever assembled'.[47] As far as can be determined, the evidence confirms this last statement. While a few Australian photographers had produced photographic books of single locations such as Sydney or Melbourne, and the great Australian photographer and filmmaker Frank Hurley (1885–1962) had travelled and photographed in central Australia as early as 1913, Hoppé's *The Fifth Continent* was the first photographic book about Australia to present a comprehensive picture of the country.

Gael Newton believes that Hoppé's book represented the only one 'in the modern style for an external market' by a foreign photographer until *The Australians*, the best-selling book by the American photographer Robert B. Goodman, which only appeared in 1966.[48] After World War II and into the 1950s several books by Oswald Ziegler Publications in Sydney presented collections of photomontage-like images of Australian life, which Martyn Jolly considers the inauguration of the 'pictorial genre of Australiana', and Hurley produced several picture books about Australia in the 1940s and 50s.[49] But nothing at this early date compares with Hoppé's comprehensive presentation in a documentary style of the Australian land and people.

Despite what we now see as *The Fifth Continent*'s groundbreaking status, Australian reception of the book was muted. The timing of its publication could certainly have been a factor in its limited press. The Depression was by 1931 in full swing, with people expressing little interest in travel

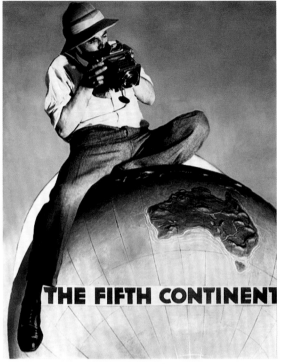

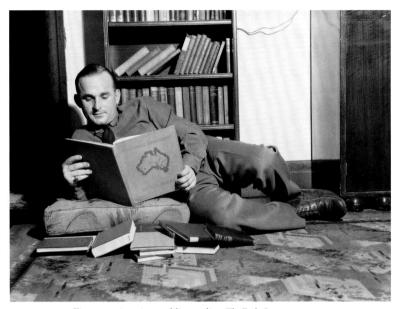

Figure 33. Original photomontage for *The Fifth Continent*, 1931

Figure 34. American soldier reading *The Fifth Continent*, c. 1943

or the purchase of travel books. Distressing political events in Germany also began to have an impact on the publishing world. The book did seem to have made its way into at least a few Australian homes, however. A photograph in the collection of the Australian War Memorial shows an American soldier reading *The Fifth Continent* while visiting 'in a cosy suburban villa in one of Australia's biggest cities' during World War II [Figure 34].[50]

Hoppé's book nonetheless almost entirely disappeared from the history of photography in Australia, perhaps because it was seen primarily as a travelogue aimed at tourists rather than as serious photographic art. The photo historian Jack Cato does not mention Hoppé or his visit in his *The Story of the Camera in Australia* (1955), although Cato had worked in London with the Australian photographer H. Walter Barnett (1862–1934), with whom Hoppé was also acquainted. Cato surely knew about Hoppé's visit, and may even have met with him while he was in Melbourne. In *Picturing Australia* (1988), Anne-Marie Willis does mention Hoppé's visit to Australia, and even reproduces one of his images from *Romantic America* over the page from Cazneaux's later industrial photographs for B.H.P., suggesting their parallel styles.[51] But she fails to consider *The Fifth Continent* in her account. Gael Newton, in *Shades of Light* (1988) is the only writer on Australian photography who acknowledges the book's appearance, calling it 'one of the earliest national photographic coverages by an art photographer, anticipating Frank Hurley's stream of picture book publications on Australia in the 1940s'.[52] All other writers, even those discussing travel photography about Australia, seem to have overlooked Hoppé's accomplishment.

Figure 35. E. O. Hoppé, In the hills near Inverell, New South Wales, 1930

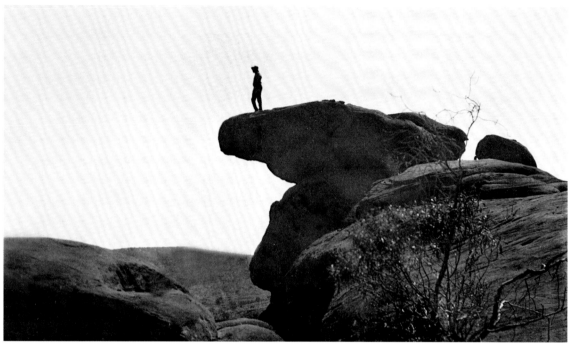

Figure 36. E. O. Hoppé, *Near Hermannsburg*, 1930

THEMES

By the time Hoppé took on the task of travelling through Australia to create a photo book, he had already completed several travel books for *Orbis Terrarum* and other publishers, and had worked as a photojournalist for ten years. His experience producing *Romantic America* had solidified his preferred compositional devices and determined the photographic themes that would appear in his Australian book. These themes encompass the full gamut of Hoppé's aesthetic modes, demonstrating the depth of his involvement in the construction of twentieth-century art photography.

CITYSCAPES/LANDSCAPES

In his photographs of the Australian landscape, both urban and natural, Hoppé reveals that he was never a purist in terms of his visual vocabulary, but incorporated Pictorialist, modernist, and even earlier artistic ideas into his photographic compositions. In many scenes he composed the image with a framing device along one side, or with a bisecting tree trunk in the foreground. He demonstrates here that his modernism was informed by an appreciation for the well-established compositional motifs found in paintings by such Romantic artists as the German painter Caspar David Friedrich (1774–1840), or indeed, the landscape elements evident in the British painter John Glover's views of Tasmania in the 1830s. The Friedrich comparison is especially apt when describing Hoppé's views in the Australian mountains [page 96]. The reviewer in *Geographical Journal* recognized this debt to Romanticism when he pointed out 'the skill of his use of dead timber in the foreground [Figure 35]'.[53] When Hoppé included figures in such views, they were most often viewed as small specks standing in awe of nature, as a means of enhancing the scale of a majestic, usually rocky, element [Figure 36].

Hoppé applied these graphic devices to many of his city scenes and streetscapes. 'Old Fleet and Rialto Buildings on Collins Street, Melbourne' is also typical of his compositional method, showing compression of space within a flattened picture plane [page 106]. The study of ordered Victorian architectural form becomes a metaphor for a tidy well-groomed city, one that Hoppé described in *The Fifth Continent* as 'Melbourne, the urbane', with 'an almost unbelievable atmosphere of the typical cathedral city of England surrounded by a belt of factories. . .'.[54] Indeed, in many of Hoppé's urban views, city streets are reduced to geometric shapes and forms [pages 44, 55, 56, 58]. Although they function as journalistic documents, this modernist emphasis on pattern and abstraction also gives them artistic resonance.

Other graphic elements included doorways and windows, which did double duty in Hoppé's photographs: They were framing devices, and they provided transition from indoor to outdoor space. His image of 'Maggie, the Bush Poet' in the Northern Territory [page 184], expresses this strategy clearly. A young girl appears relaxed, looking out a window of a tin building, into what must have been the scorching heat of a desert day.

TYPES

Long before Hoppé had abandoned his fashionable studio practice for photojournalism, he had already shown an interest in "character studies," as he called them. As Phillip Prodger writes, 'in an era in which eugenics had many followers, Hoppé questioned whether it was possible to see a person's destiny inscribed in his or her appearance'.[55] This kind of typological thinking was the initial impetus behind his study of feminine beauty, *The Book of Fair Women*, as well as his *London Types* (1926), and *Taken from Life* (1922). Just as he had looked for the quintessentially "American" type when he produced *Romantic America*, he sought to capture the Australian character in authentic specimens of 'the human element' that he found in out-of-the-way places. These photographs differed from his formal portrait sittings, although at least one of these portraits, that of Dorothea Mackellar, seems to impart the same sense of intimacy and revelation. For such studies he tried to portray them as close-up 'head shots' against neutral backgrounds, or in some cases, with a few props within the poser's occupational surroundings.

In *The Fifth Continent*, only five of his 'types' appeared: 'Mr Brown, sheep farmer, Tasmania', [page 155]; 'Mine Host at Eden. N.S.W.', [Figure 38]; 'W. H. Beecher, fruit-grower, Tasmania', [Figure 24]; 'Old miner, Kalgoorlie, Western Australia', [Figure 39]; and 'Young axeman in Kauri Forest, Western Australia', [page 157]. Hoppé was able to publish some of these other portraits in subsequent journal articles—his fascination with Minnie Barrington of Coober Pedy, for example, led to many articles in which she figured along with her portrait [Figure 37]. However, his stated desire to produce a book dedicated to these images of Australian characters never came to pass, nor do they appear to have been displayed together in an exhibition. This is unfortunate, for these photographs do present a fascinating picture of Australians as they appeared in 1930.

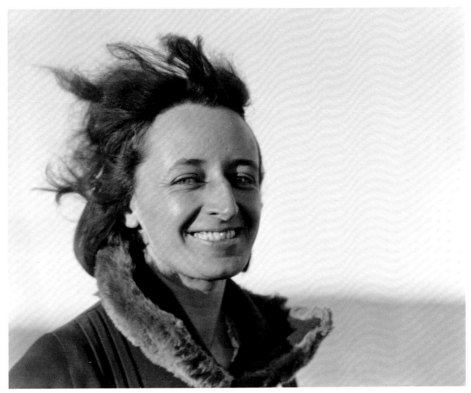

Figure 37. E. O. Hoppé, Minnie Barrington, Coober Pedy, 1930

Figure 38. E. O. Hoppé, Mine Host at Eden, New South Wales, 1930

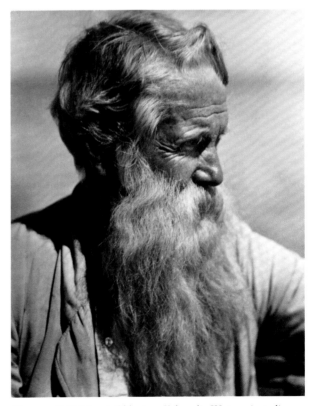

Figure 39. E. O. Hoppé, Old miner, Kalgoorlie, Western Australia, 1930

Hoppé occasionally depicted an idea, often humorous, through the simple juxtaposition of seemingly incongruous objects, particularly signs. These could be announcing 'tea cup readings' in a Melbourne shop [page 107] or boasting a Tattersals lottery ticket with every suit sold at a tailor's shop somewhere in the New South Wales countryside [page 109]. Signs also provided narrative detail, as in his image Aboriginal girls at Hermannsburg looking at a movie poster [page 167]. In his streetscapes, too, he sometimes portrayed shop-fronts or other buildings with textual messages [pages 64, 95, 122, 142, 192]. At other times, signs accentuated the Outback curiosities, such as the Commonwealth Bank sign next to the Post Office sign at the entrance to a Coober Pedy tunnel [page 138]. Signs also played a part in his pictures of the Royal Easter Show [pages 77–79].

LABOUR AND INDUSTRY

Fresh off his publication of industrial images in *Deutsche Arbeit,* Hoppé was looking for similar examples to photograph in Australia; he found them in Kalgoorlie [page 148] and Newcastle [pages 149, 150].

But the most exciting, the most modern industrial images he produced in Australia were those of the construction site of the Sydney Harbour Bridge—then the focus of nearly every modern artist and photographer in the city. He included glimpses of the bridge as it appeared in the distance across the rooftops of Sydney or viewed as a misty geometric form from street corners. His greatest series of photographs of the bridge occurred on site, where the masses of cables and intersecting beams allowed him to create patterns and repetitions of form that are as powerful as any created by his American peers, such as Edward Steichen or Walker Evans (1903–1975), or the German Albert Renger-Patzsch [pages 43–53].

ABORIGINES

Travelling to the Northern Territory and to the Aboriginal communities in Queensland gave Hoppé a unique opportunity to record ceremonies and evidence of traditional life at a time when very few Europeans—and certainly none with as much photographic experience—had travelled in the region.[56] His visit to Hermannsburg was particularly poignant.[57] His ideas of ethnology in many ways grew out of the same philosophy that led him to study 'types'; he believed that character could be divined from portraits.

Hoppé's images of Aborigines retain extraordinary power. While some of the dances and ceremonies may have been staged specifically for him (he says as much in *The Fifth Continent*), those participating in the performances were still closely enough tied to their traditional life that they are convincing in their movements and displays [pages 174–178, 181–183]. The images that he made at the lamentable Palm Island community portray ceremonies and dress with intimate detail —so much so that many of them should not be exhibited outside of the Aboriginal community itself.[58] In terms of Aborigines at the missions—both at Hermannsburg and at New Norcia—Hoppé documented those in the process of 'assimilation' [pages 162–169].

At many points in his Australian travels Hoppé produced, with a conscious eye to commercial publication, photographic essays that he himself called 'day in the life' stories. The idea of the photo-essay flows from Hoppé's German background, as such magazines as *Berliner Illustrirte Zeitung* were the forerunners of later American magazines such as *Life* and *Look* or such British illustrated magazines as *Picture Post*. Long before the publication of the wildly popular *A Day in the Life* series (of which *A Day in the Life of Australia* was the first, in 1981[59]), Hoppé had already created several such series based on pictures about life in Australia. These included 'A Business Girl's Day', [pages 64, 65]—twenty years before Leonard McCombe's influential *Life* photo-essay on a career woman in New York City[60]—and his series comparing a middle-class and a working-class Sydney home [pages 66, 67]. The picture-story idea may also have informed his approach to the Royal Easter Show, as well as his depictions of several Sydney's unemployed and homeless [pages 73, 74]. His work in the lumber camps of Western Australia [pages 151, 154, 158, 159] and his images of the apple growers of Tasmania [pages 116, 117] all read as if they were meant to tell a story serially and without words.

Hoppé's stated aim, as he writes in *The Fifth Continent*, was to 'reflect the true spirit of Australia'.[61] In our more cynical age, such a romantic notion may seem unattainable through photographs. But the images, thankfully intact and preserved as a single archive, do present an unprecedented picture of Australia as it appeared at the beginning of the 1930s. No other photographer, Australian or foreign, had presented such a comprehensive view of the nation by that time. Still, the enduring quality in this work and Hoppé's greatest achievement in making it is that he has been able to show us what it is to be Australian.

Plates

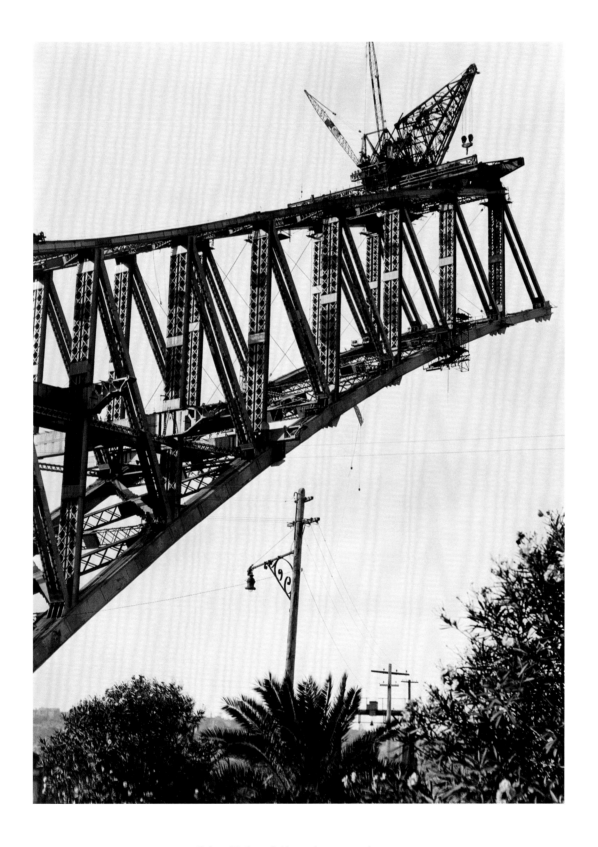

Sydney Harbour Bridge under construction, 1930

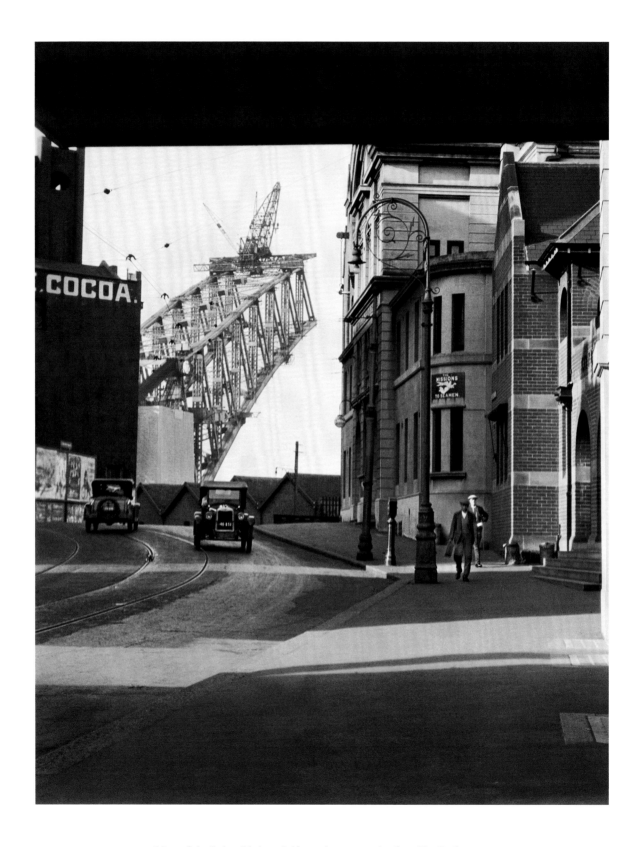

View of the Sydney Harbour Bridge under construction from The Rocks, 1930

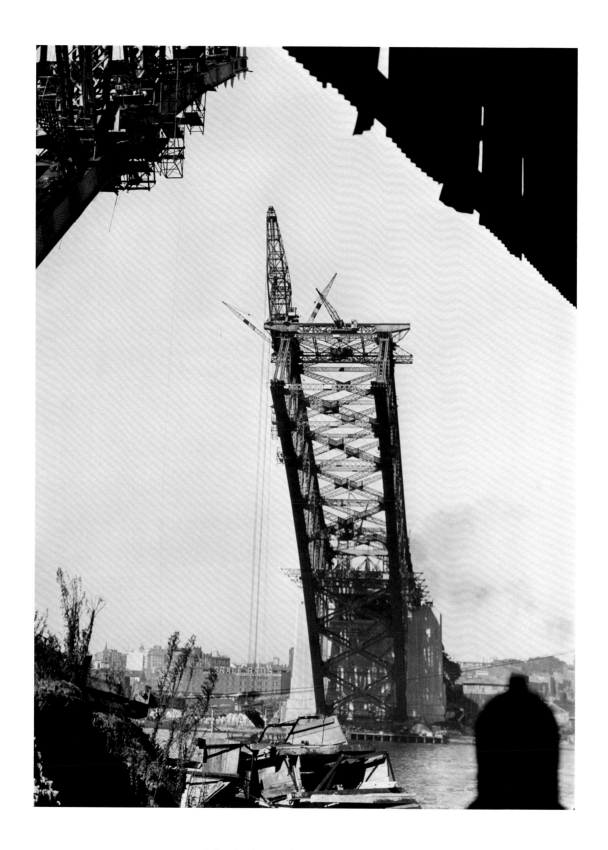

Sydney Harbour Bridge under construction, 1930

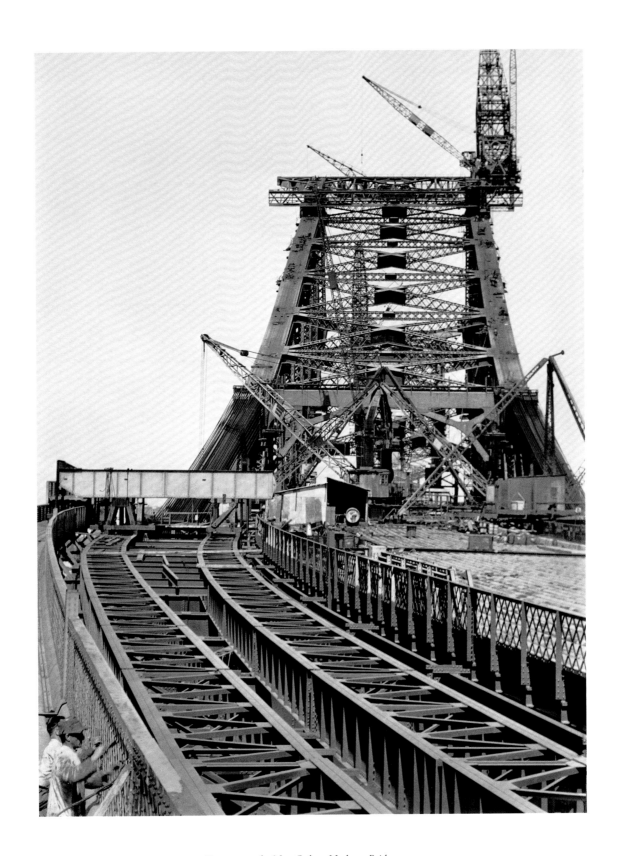

Entrance to the New Sydney Harbour Bridge, 1930

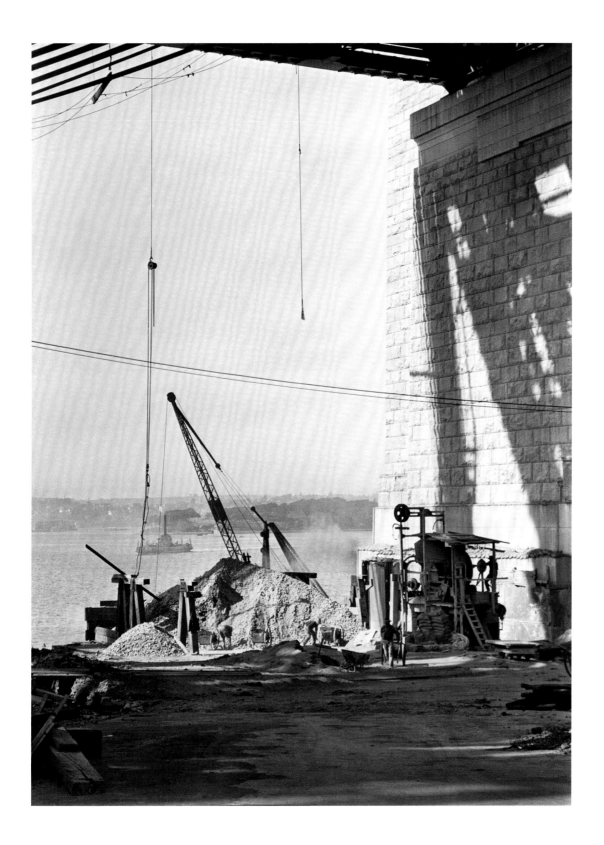

A pylon of the Sydney Harbour Bridge, 1930

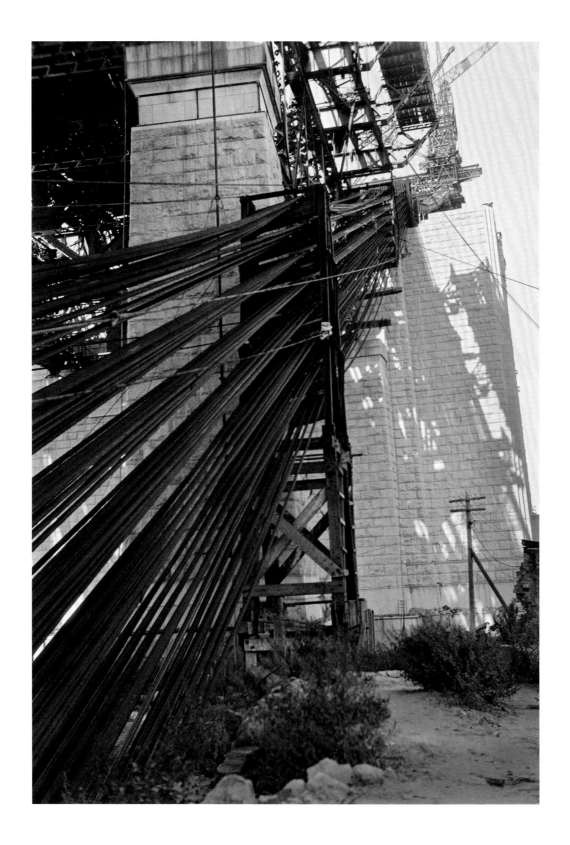

Construction on the Sydney Harbour Bridge, 1930

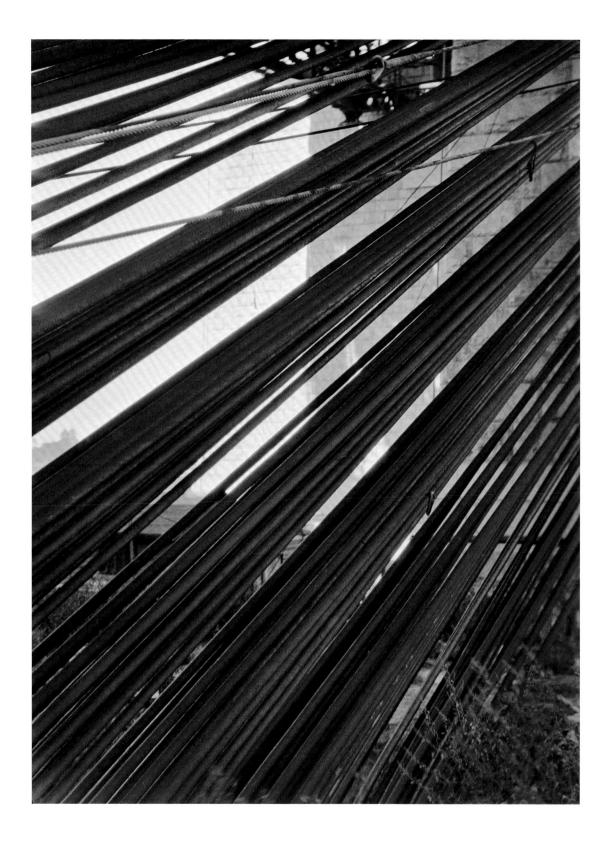

Supporting cables of the Sydney Harbour Bridge, 1930

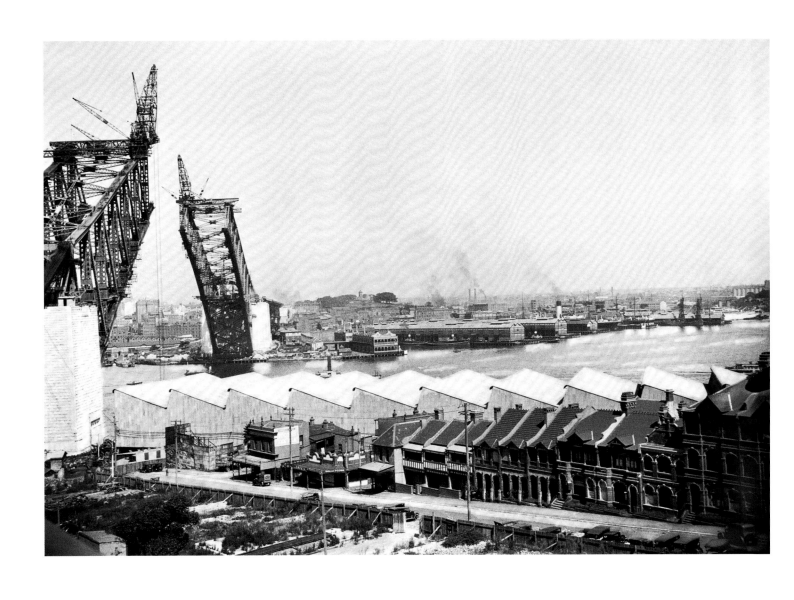

View of Sydney Harbour and the Harbour Bridge under construction, 1930

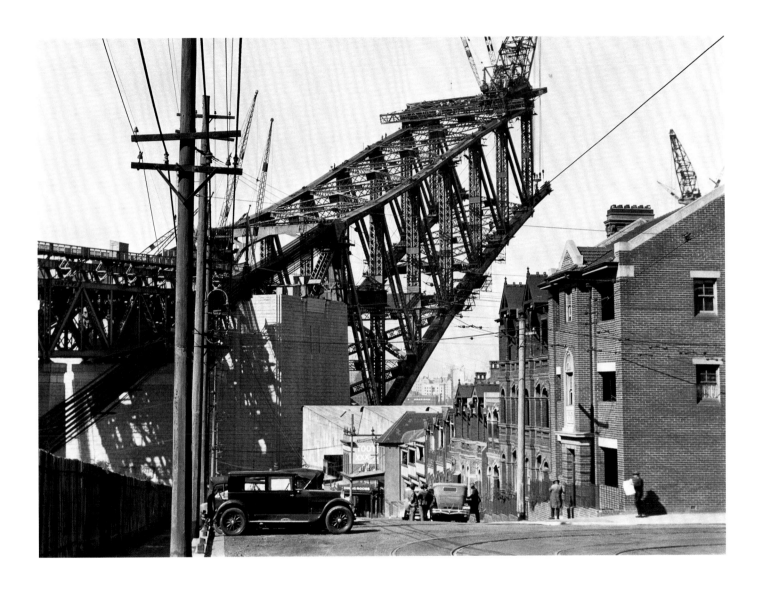

View from the city of the Sydney Harbour Bridge under construction, 1930

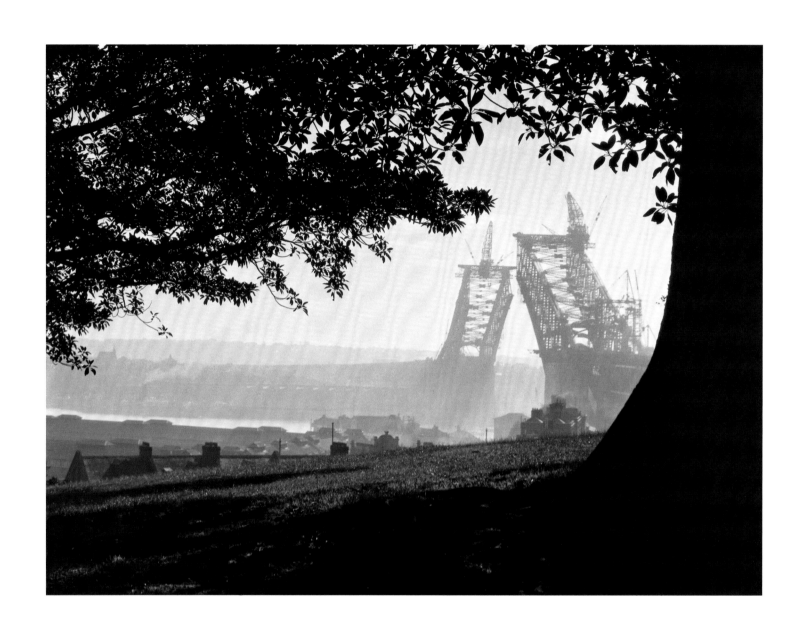

Evening over Sydney Harbour with a view of the Harbour Bridge under construction, 1930

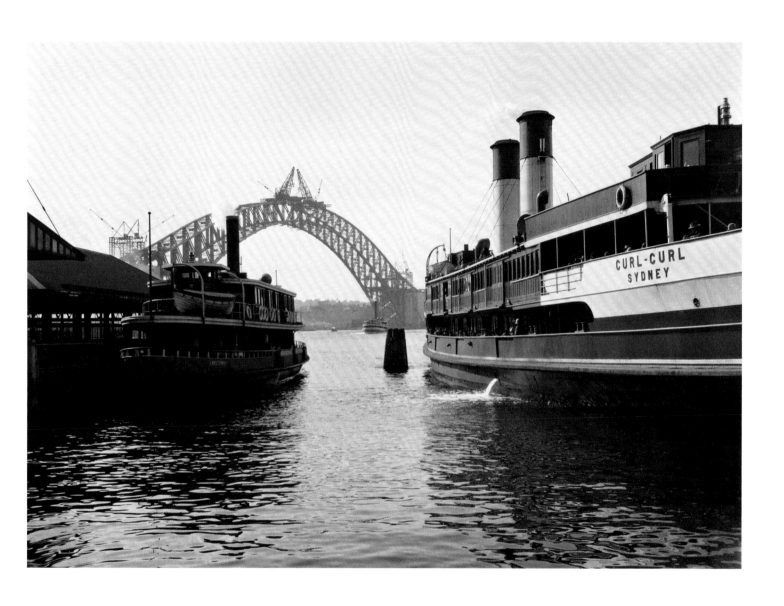

The Sydney Harbour Bridge nearing completion from Circular Quay, 1930

Circular Quay, Sydney, 1930

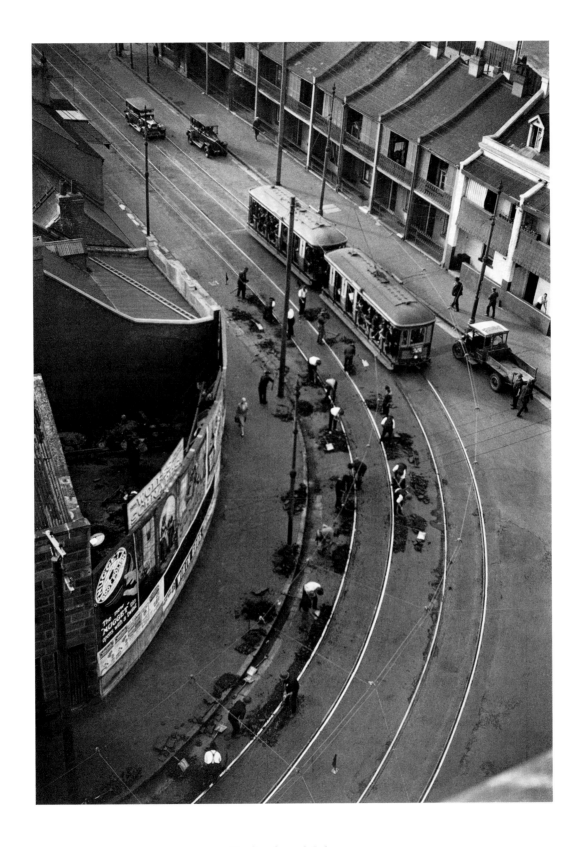

Mending the road, Sydney, 1930

Over the rooftops, Stanley Street, Sydney, 1930

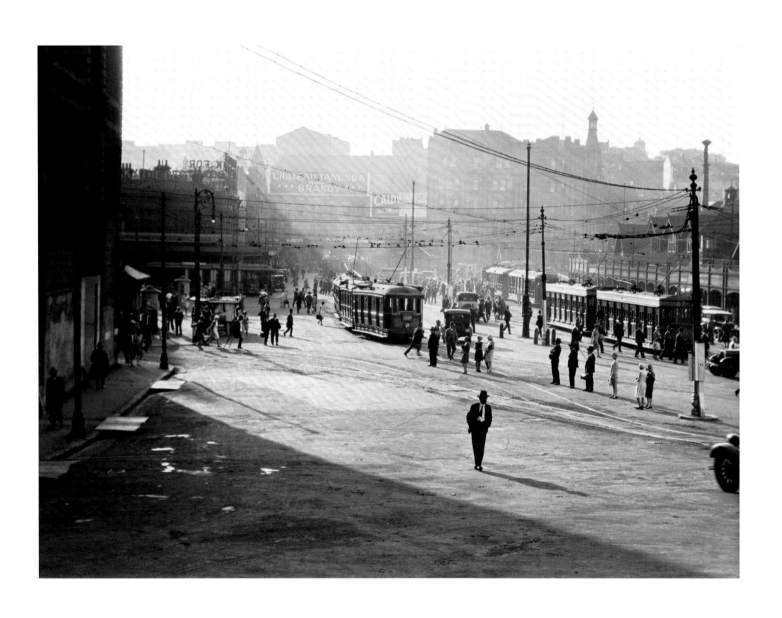

Wentworth Avenue, Sydney Railway Station, 1930

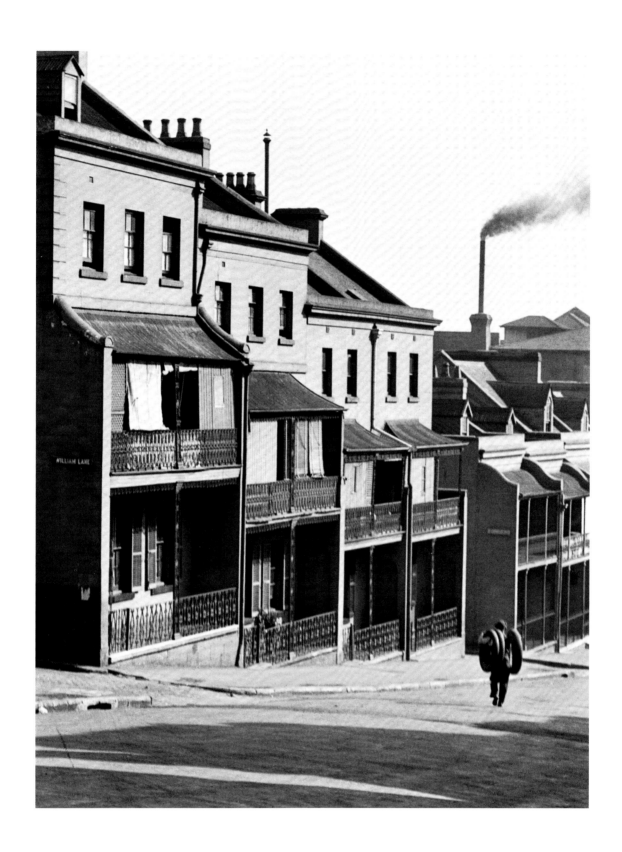

William Lane, Woolloomooloo, Sydney, 1930

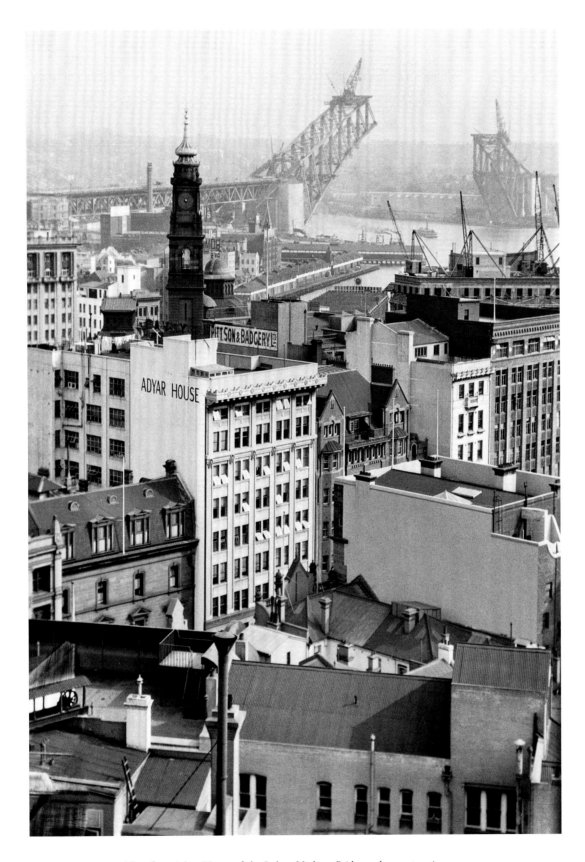

View from Adyar House of the Sydney Harbour Bridge under construction, 1930

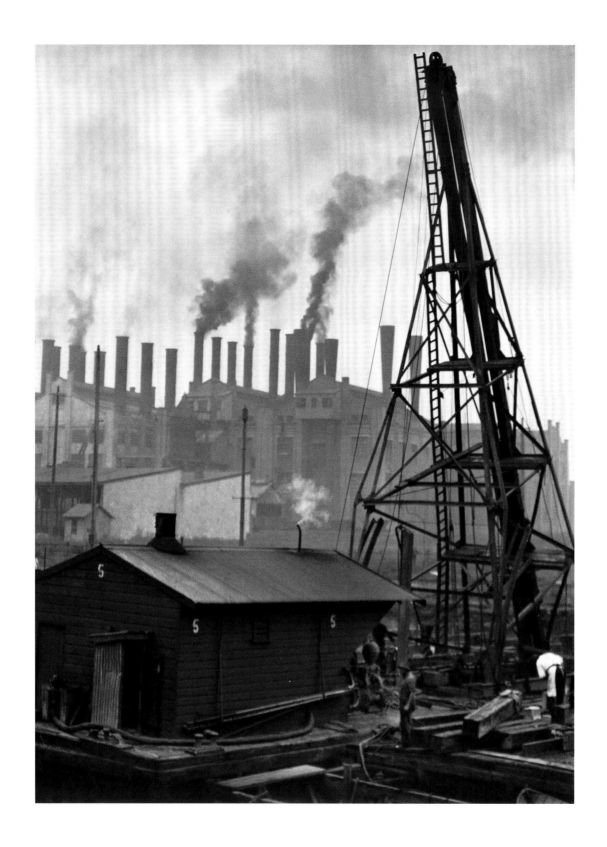

Power Station, Sydney Harbour, 1930

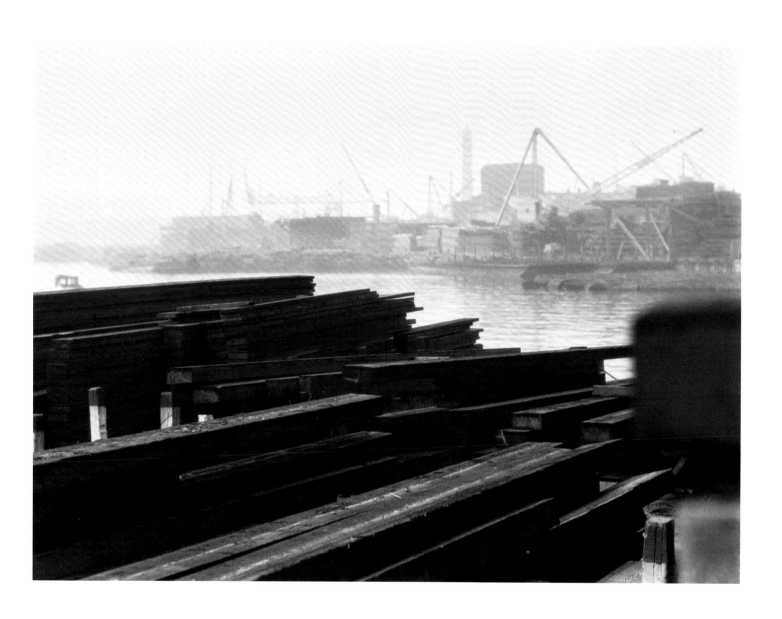

Timber, Sydney Harbour Docks, 1930

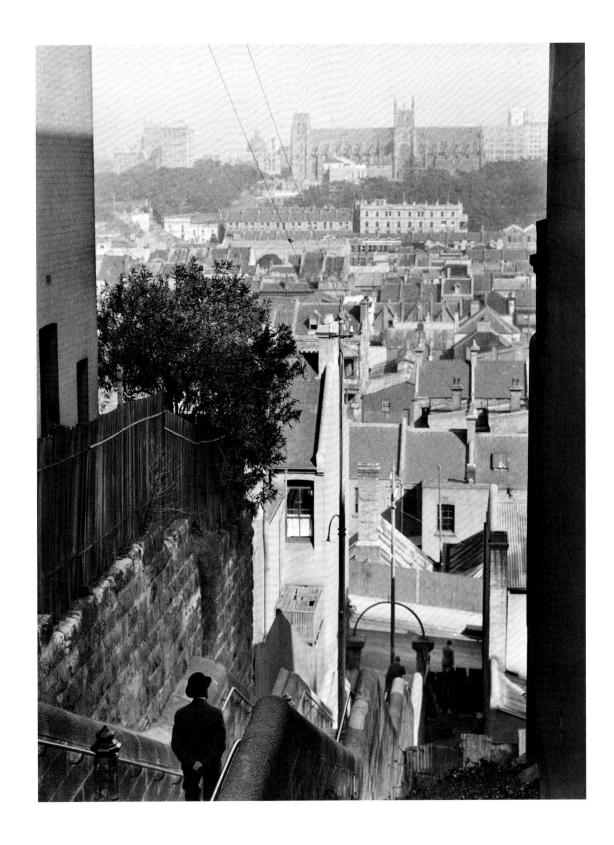

Woolloomooloo, Sydney with St. Mary's Cathedral in the distance, 1930

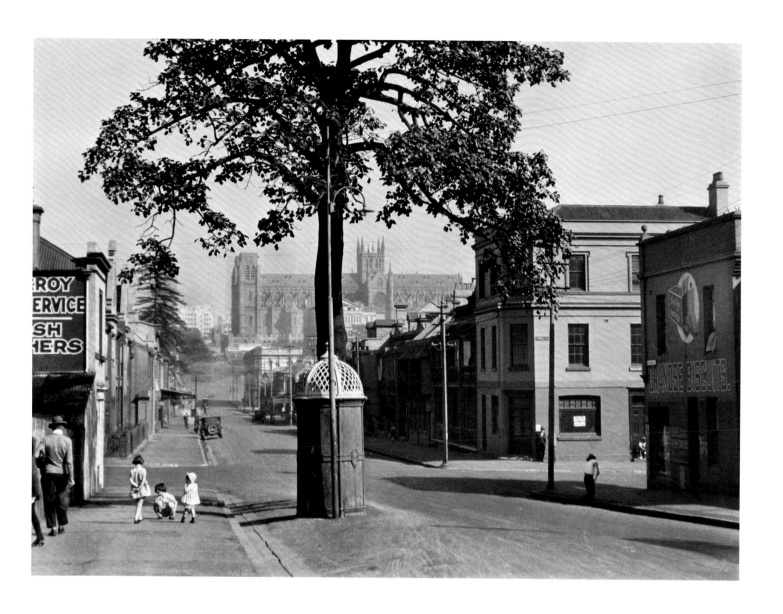

Cathedral Street, Sydney, 1930

'A Day In the Life of a Business Girl' Photo Essay, 1930

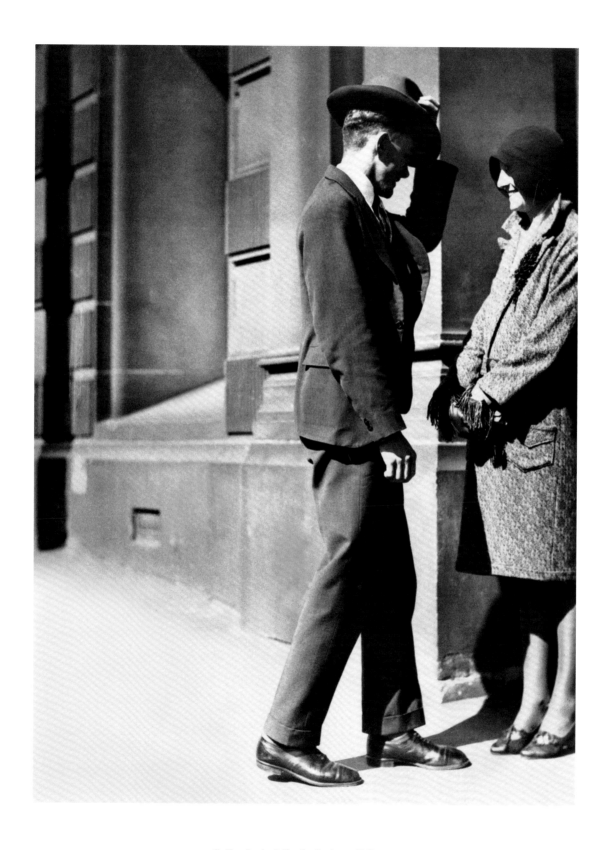

'A Day In the Life of a Business Girl', 1930

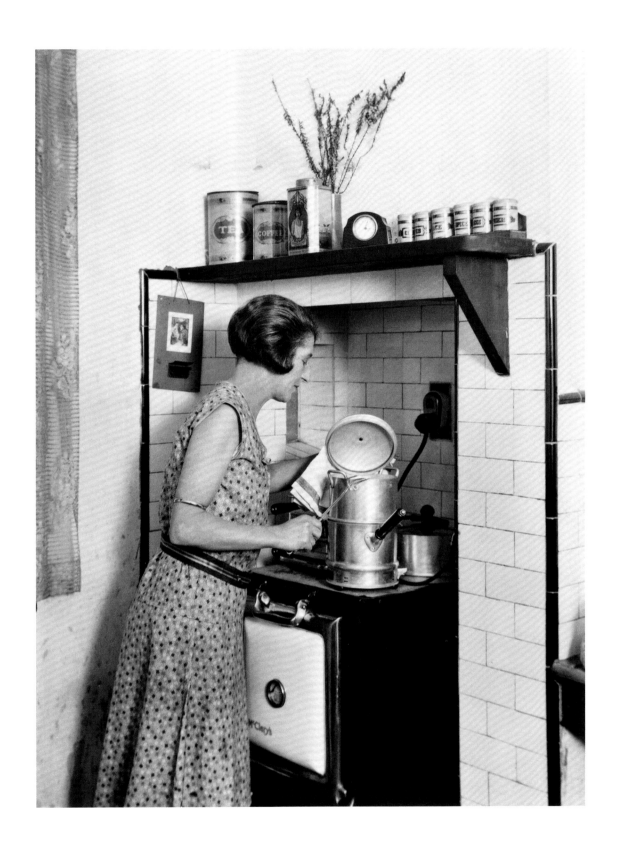

'Cooking by Electricity, The Middle-Class Home', 1930

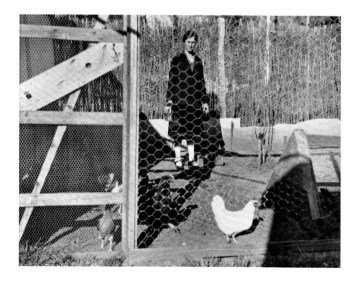

Top to Bottom: 'The Middle-Class Home', 'Children', 'Feeding the Chooks', 1930

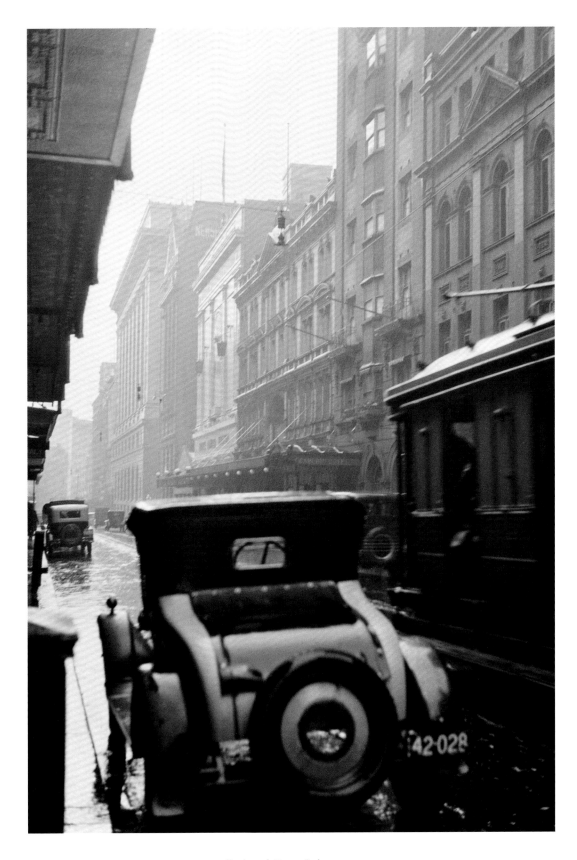

Castlereagh Street, Sydney, 1930

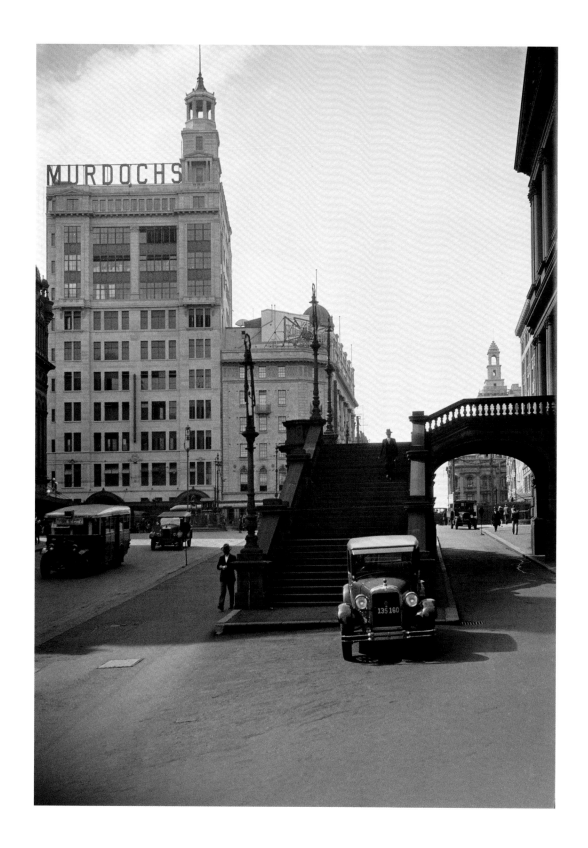

Town Hall, Sydney, 1930

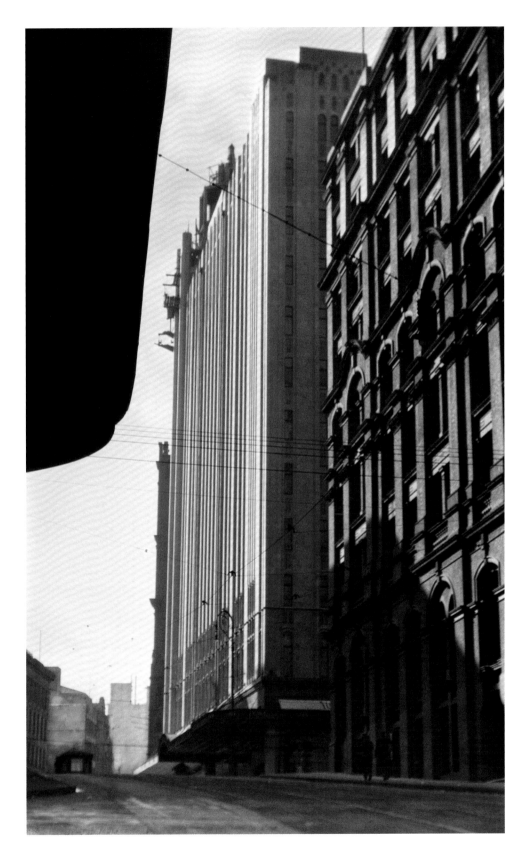

Sydney skyscraper, 1930

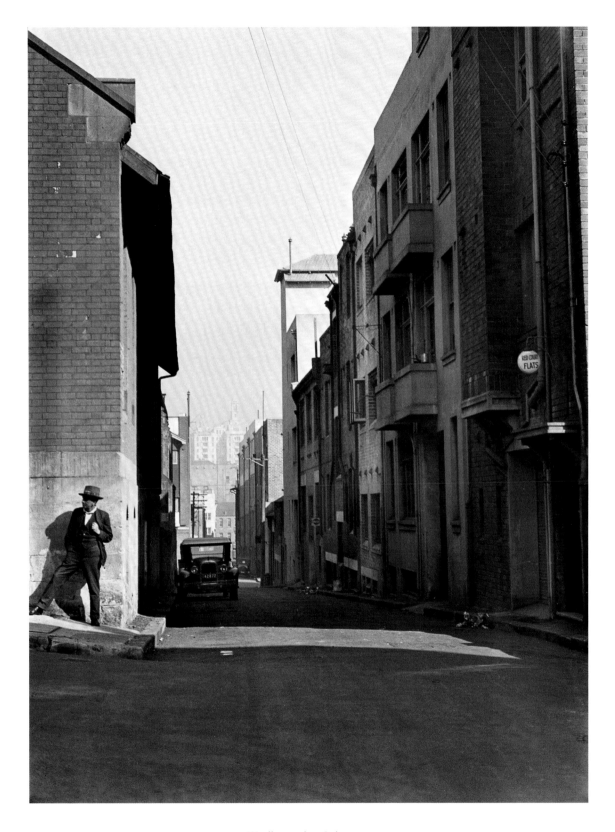

Woolloomooloo, Sydney, 1930

Elizabeth Bay House, Sydney, 1930

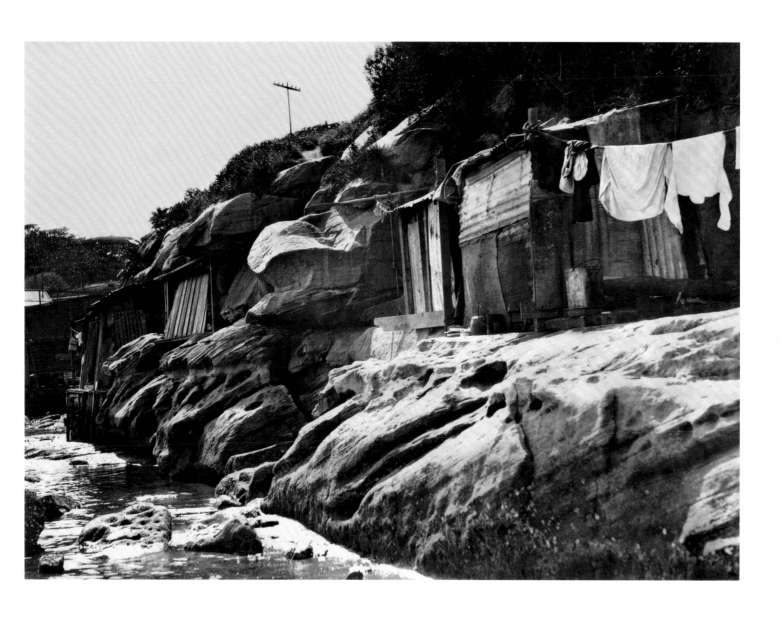

Houses of the out-of-work, 1930

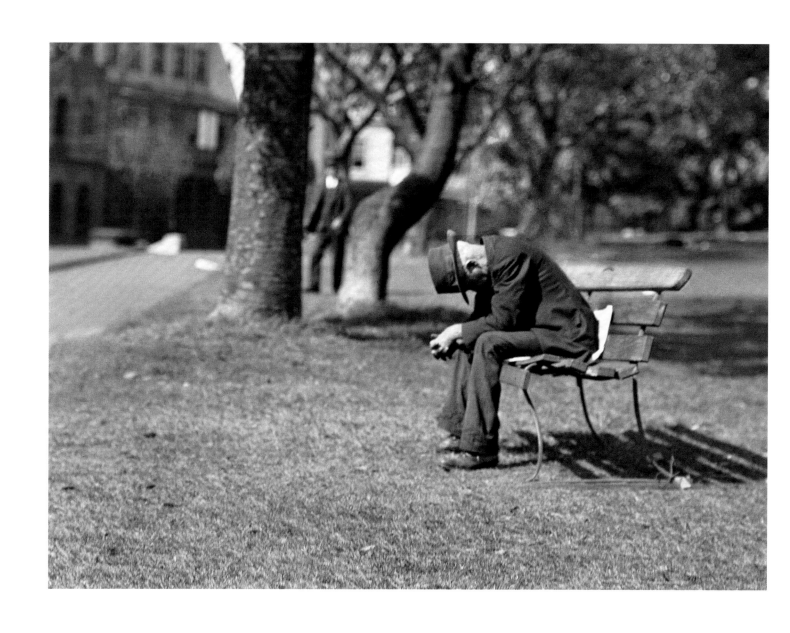

Out of work, Hyde Park, Sydney, 1930

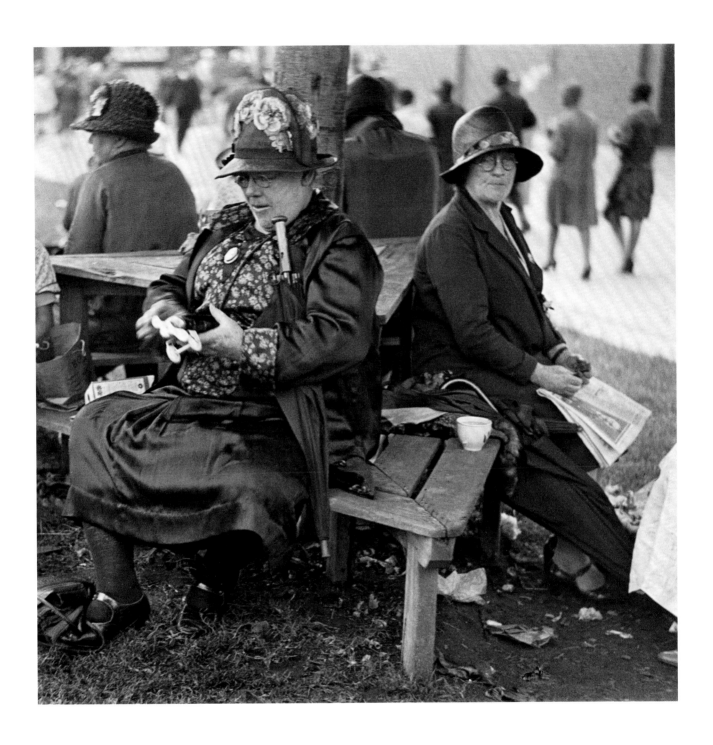

Picnicing at the Royal Agricultural Show, Sydney, 1930

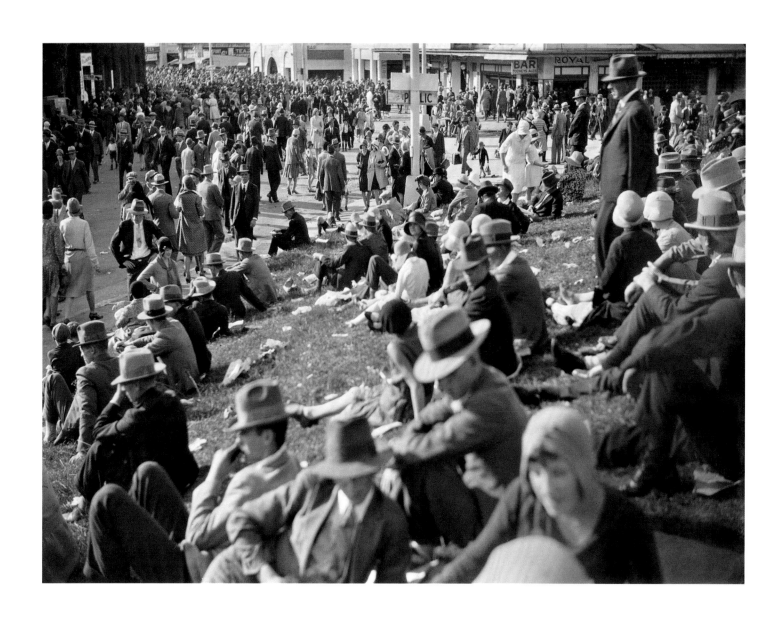

Sunday crowd at the Royal Agricultural Show, Sydney, 1930

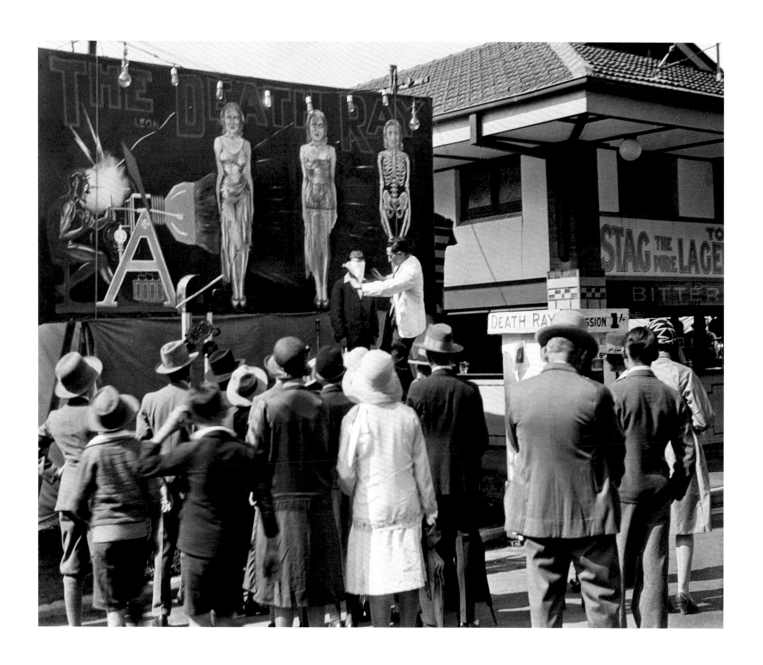

'The Death Ray', Royal Agricultural Show, Sydney, 1930

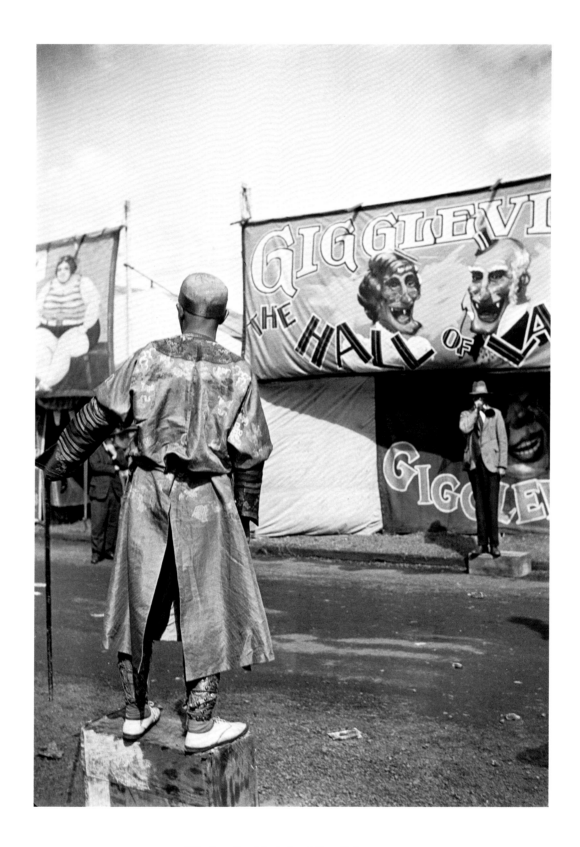

Side Show, Royal Agricultural Show, Sydney, 1930

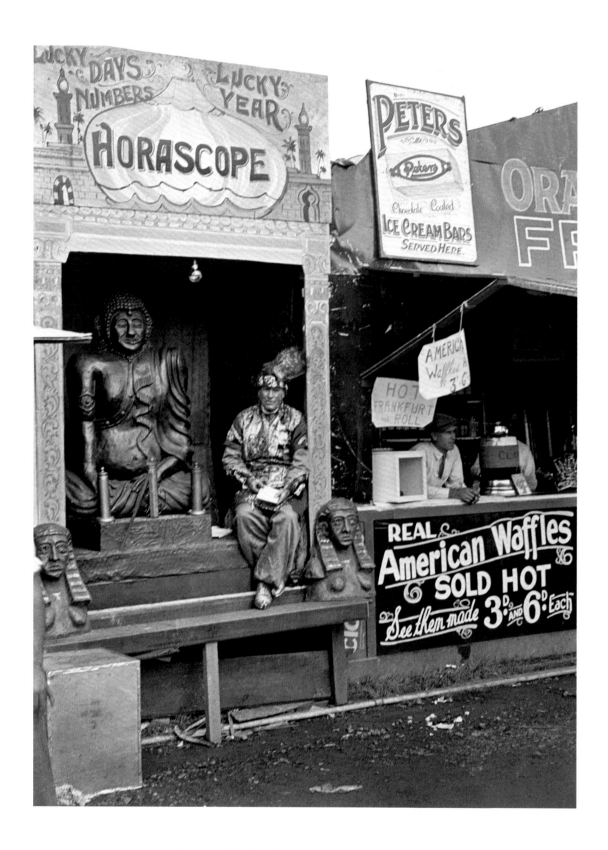

Horoscope Side Show, Royal Agricultural Show, Sydney, 1930

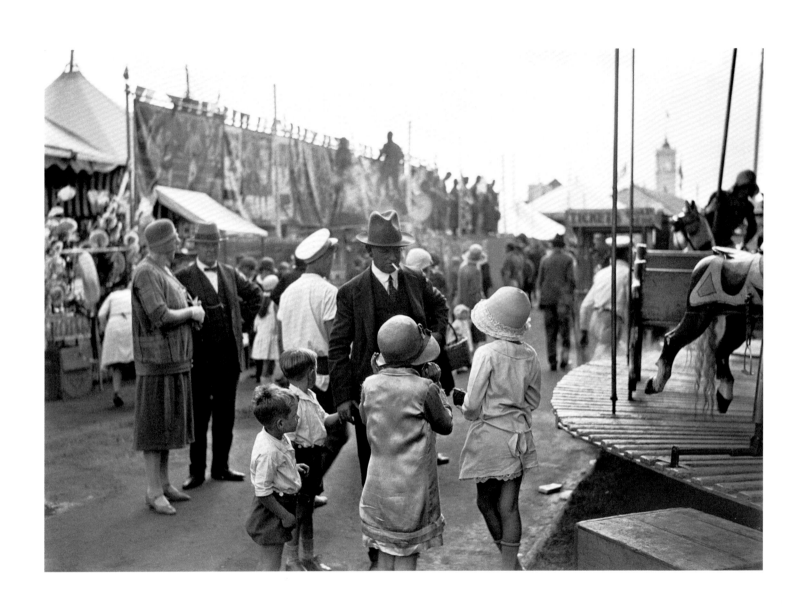

Merry-Go-Round, Royal Agricultural Show, Sydney, 1930

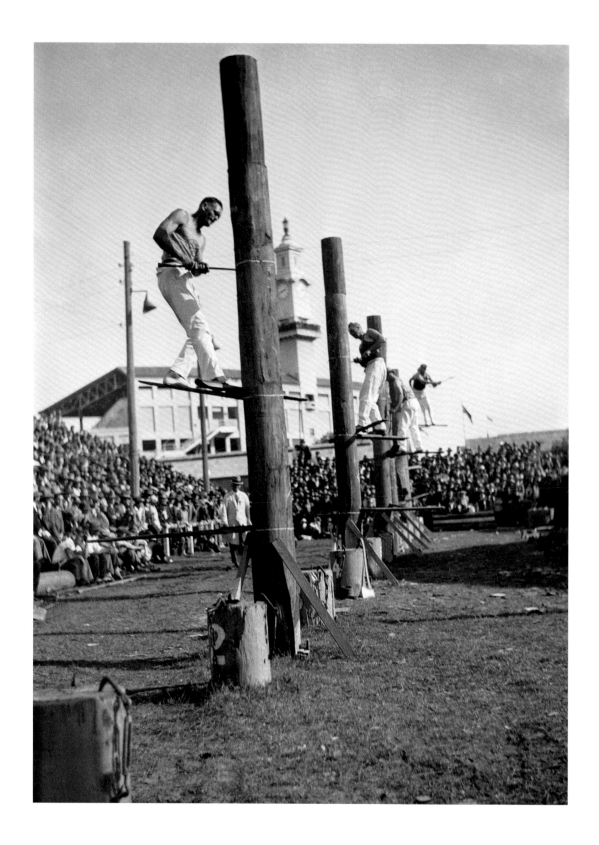

Tree-Felling Competition, Royal Agricultural Show, Sydney, 1930

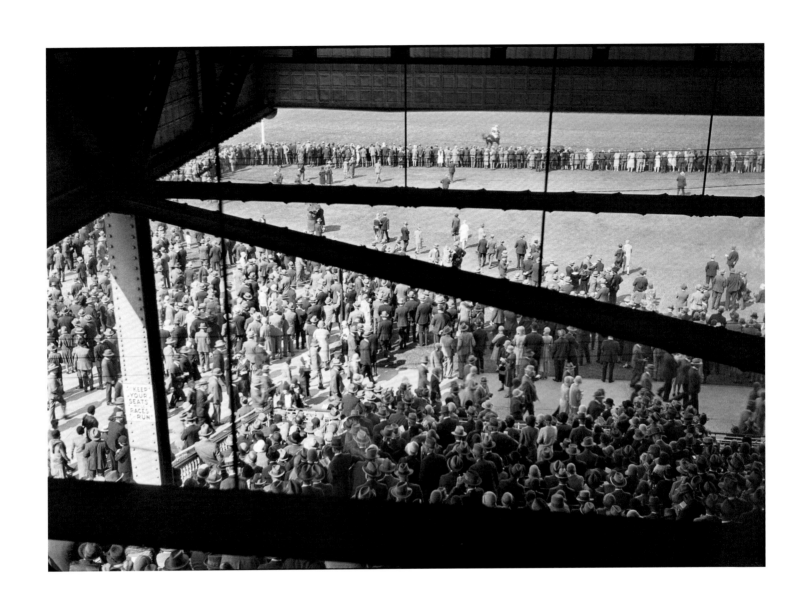

Randwick Park Races, Easter Monday, Sydney, 1930

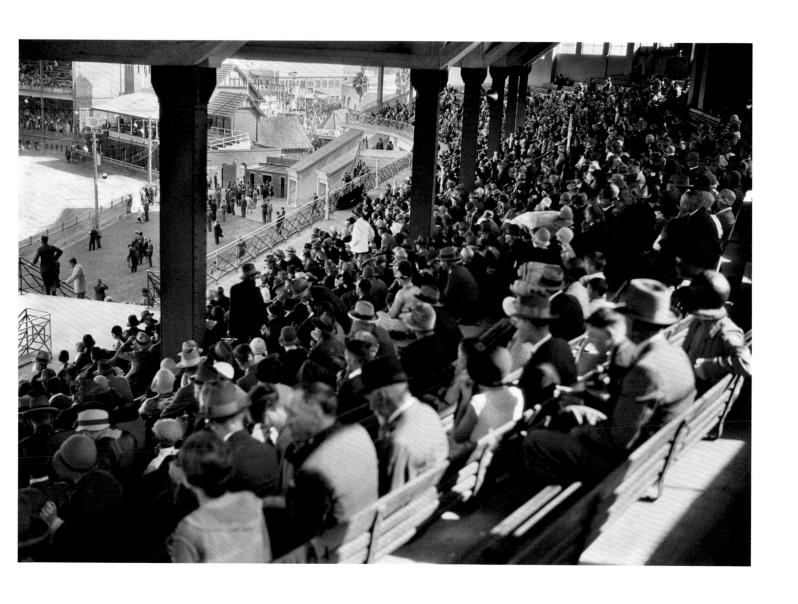

Crowds, Royal Agricultual Show, Sydney, 1930

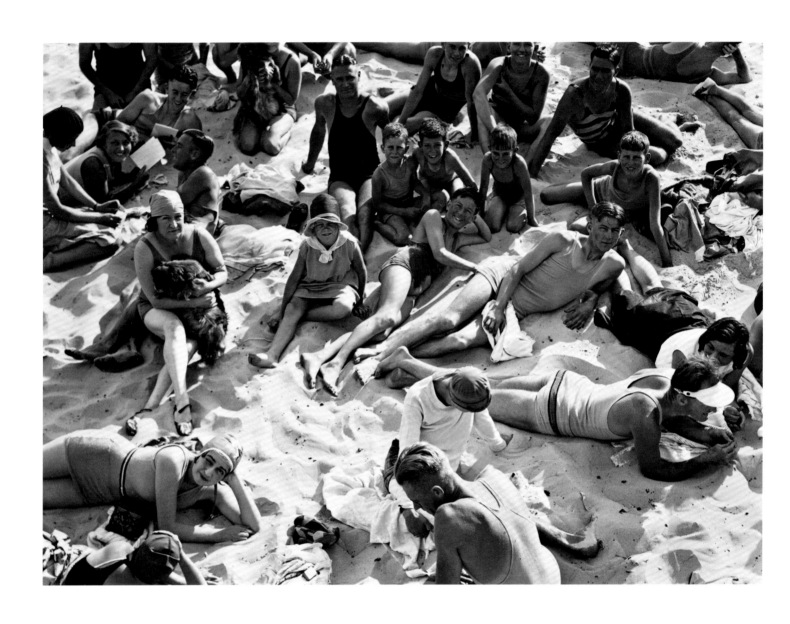

A cluster of bathers, Bondi Beach, Sydney, 1930

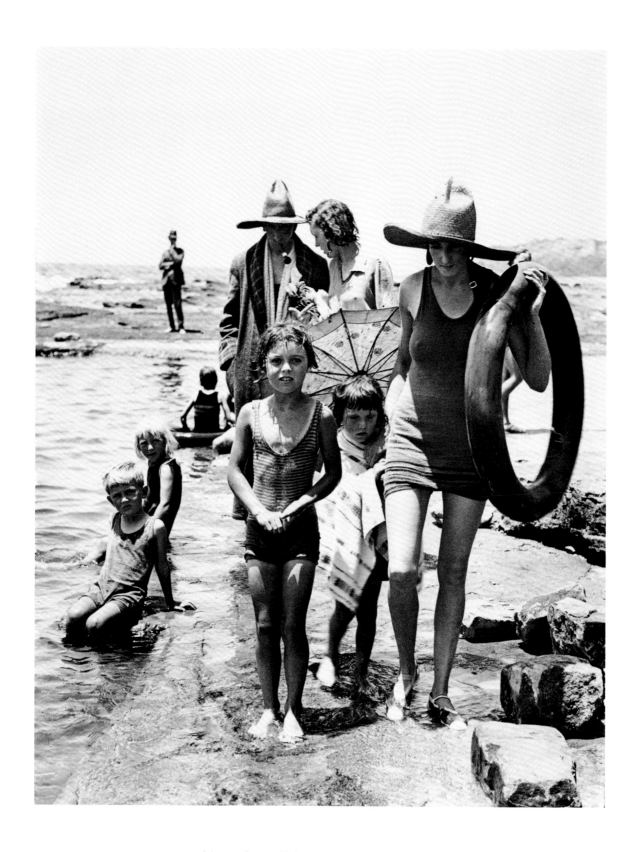

Mr A. Wilson, publisher, and family at Collaroy Beach, Sydney, 1930

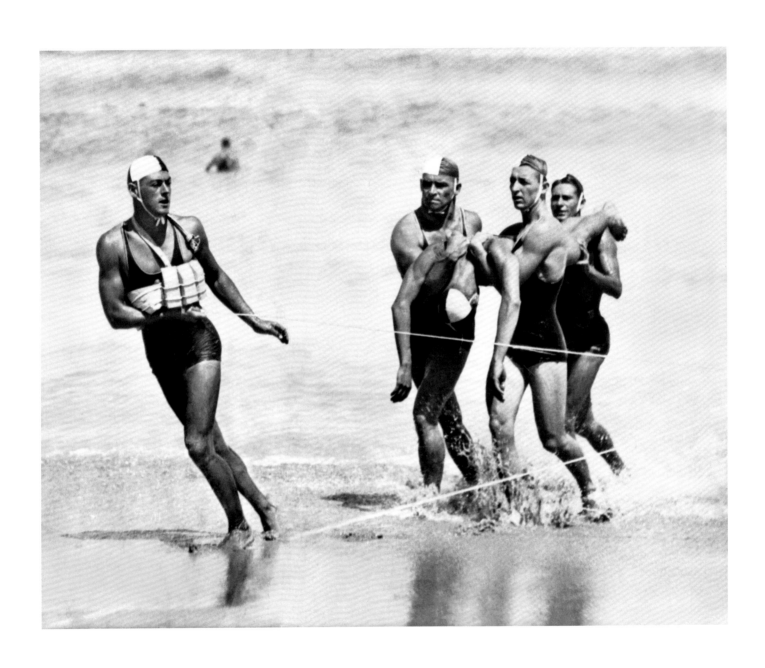

Sydney Beach lifesavers, 1930

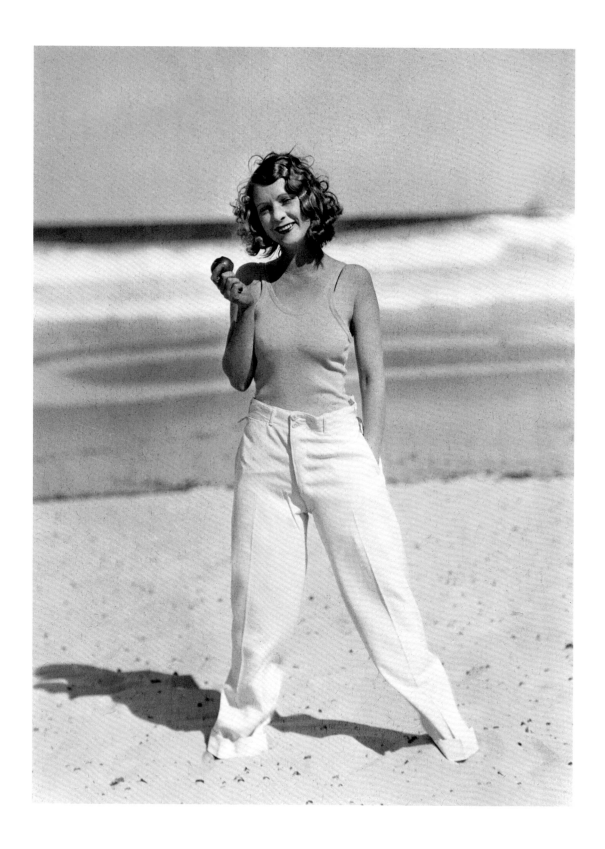

Young woman at Bondi Beach, Sydney, 1930

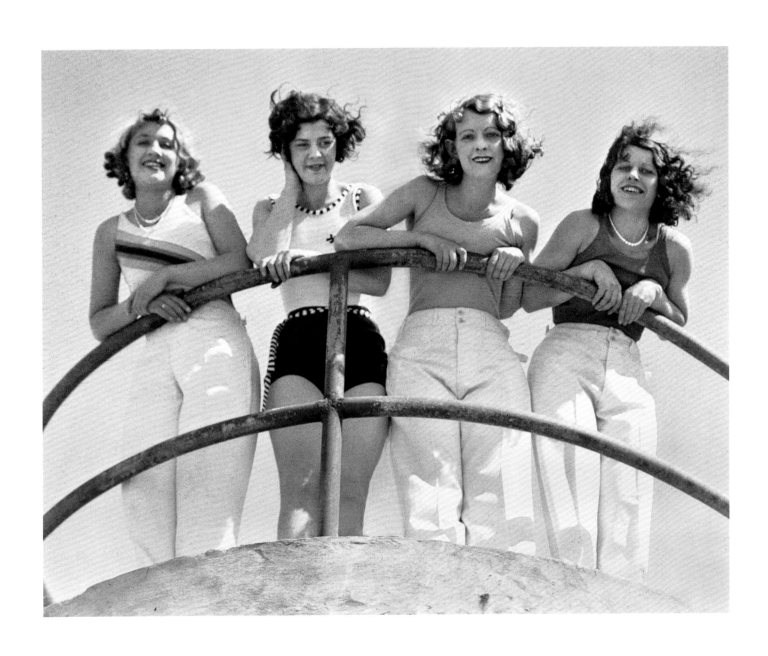

Women leaning on a railing, Bondi Beach, Sydney, 1930

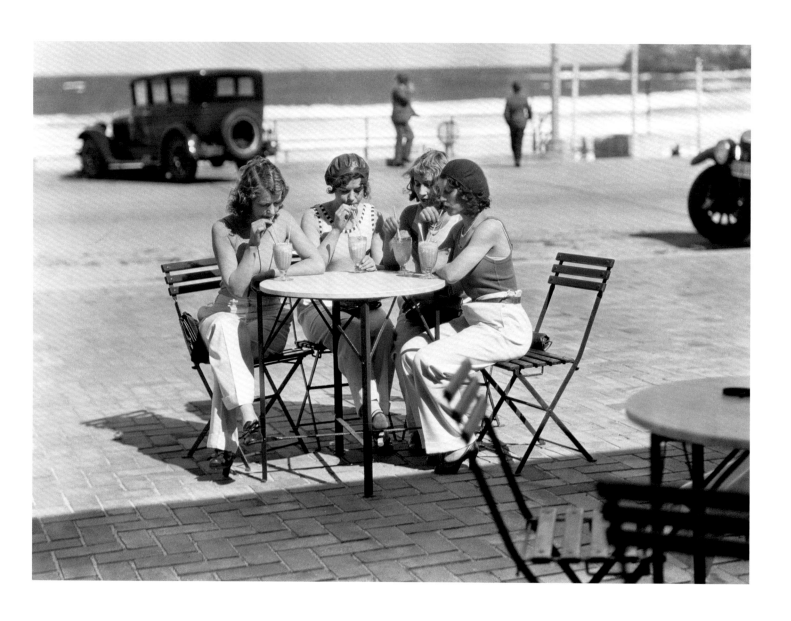

Sitting at a café, Bondi Beach, Sydney, 1930

The Melbourne and Sydney Buildings, Civic Centre, Canberra, 1930

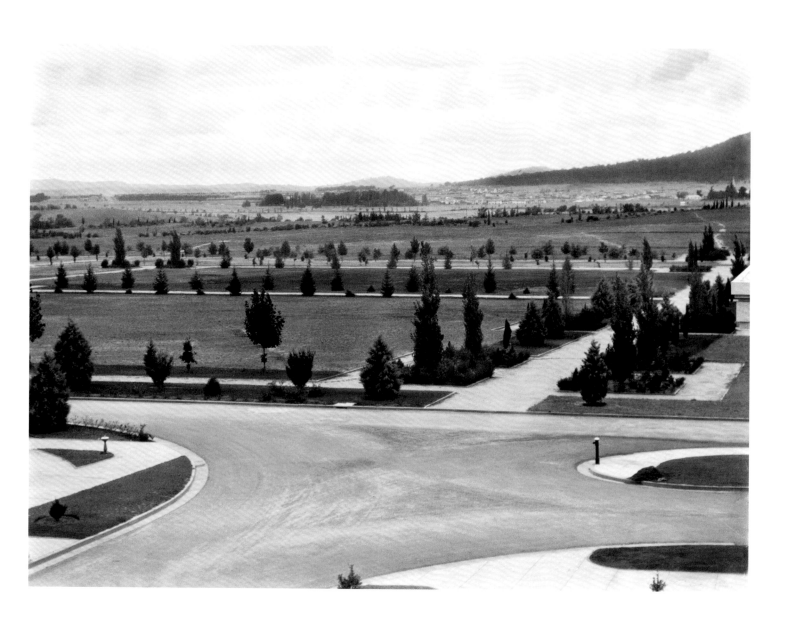

New Road, South Grounds, Canberra, 1930

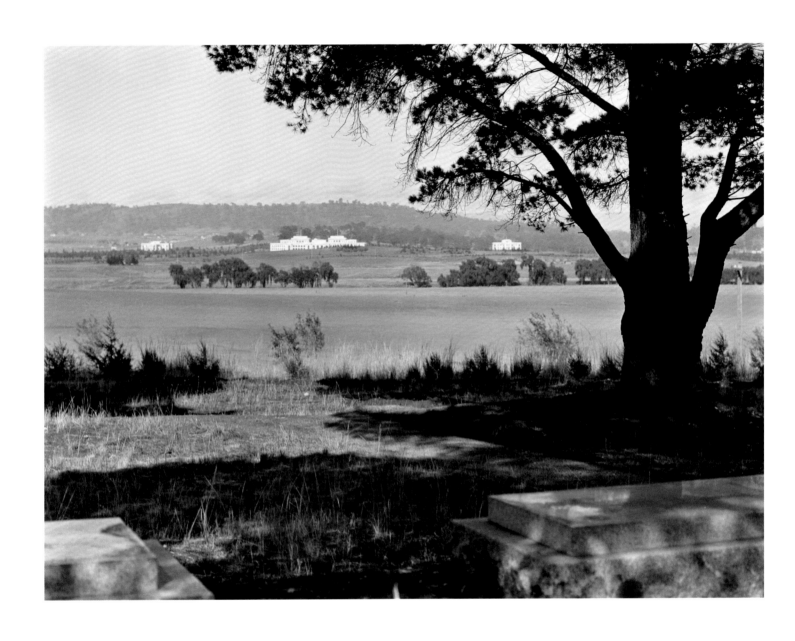

Houses of Parliament in the distance, Canberra, 1930

Kingston Shopping Centre, Canberra, 1930

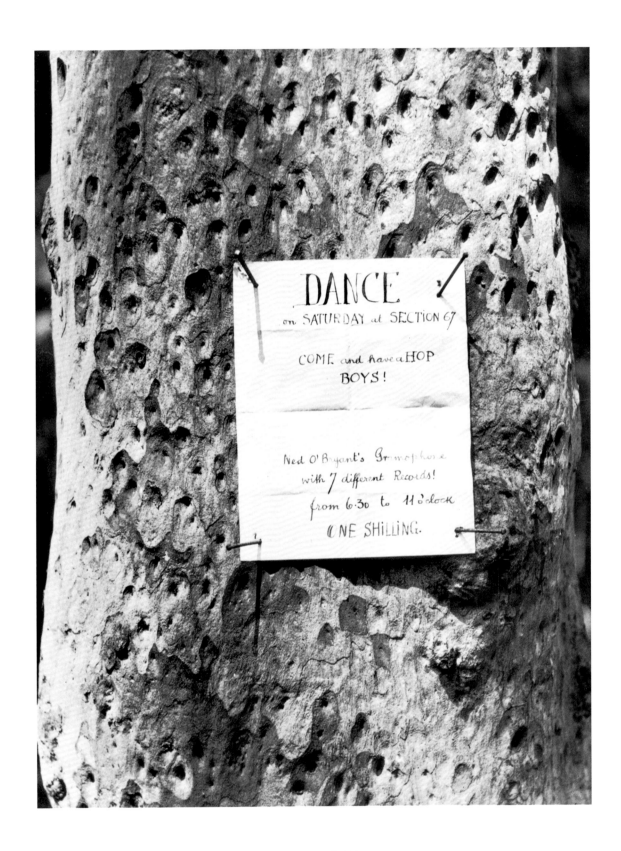

Dance sign, New South Wales, 1930

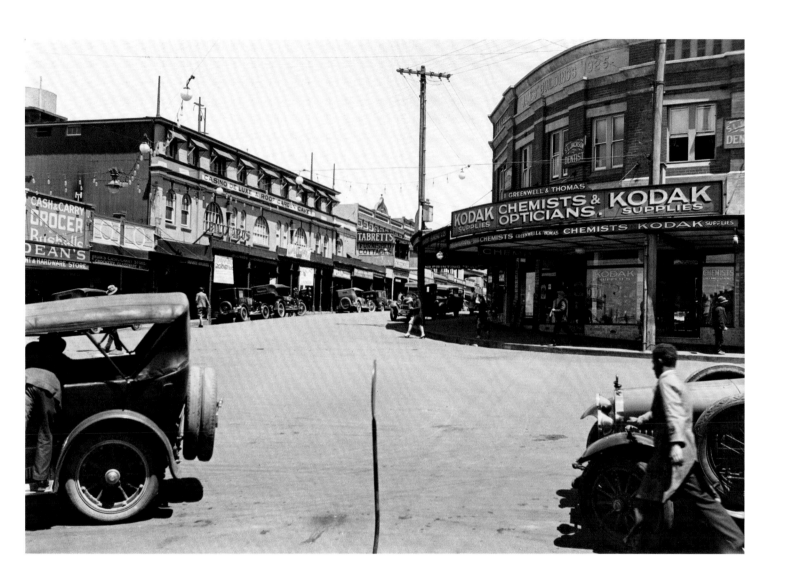

Main Street, Katoomba, Blue Mountains, 1930

Govette's Leap, Blue Mountains, New South Wales, 1930

Mount Buffalo Range, Victoria Alps, 1930

On the road to Bathurst, 1930

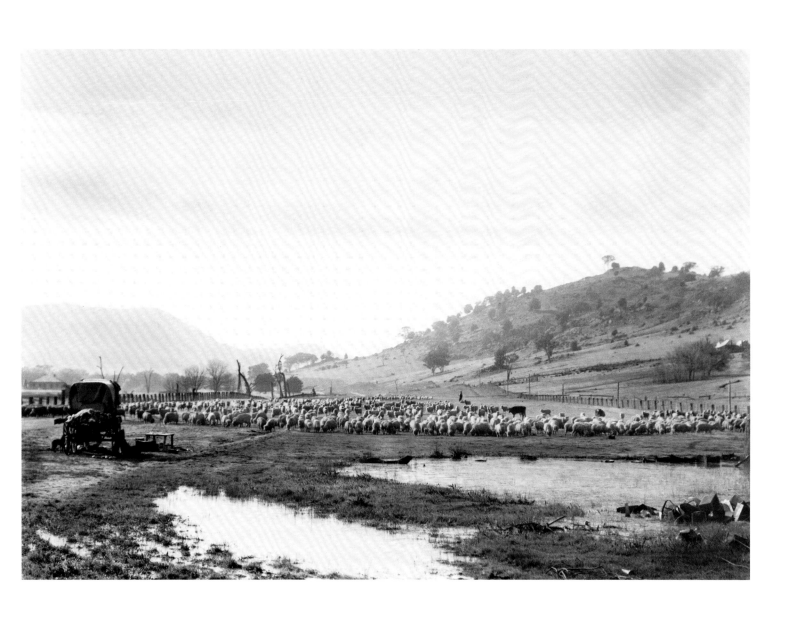

Sheep droving, Victoria, 1930

Crowds crossing Flinders Street, Melbourne, 1930

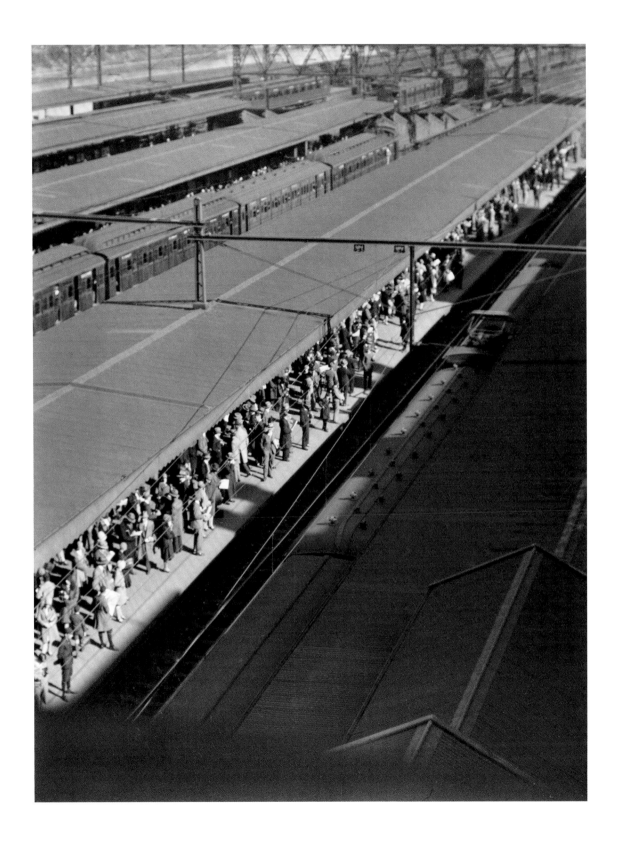

Crowded platform at Flinders Street Railway Station, Melbourne, 1930

Yarra River, Melbourne, 1930

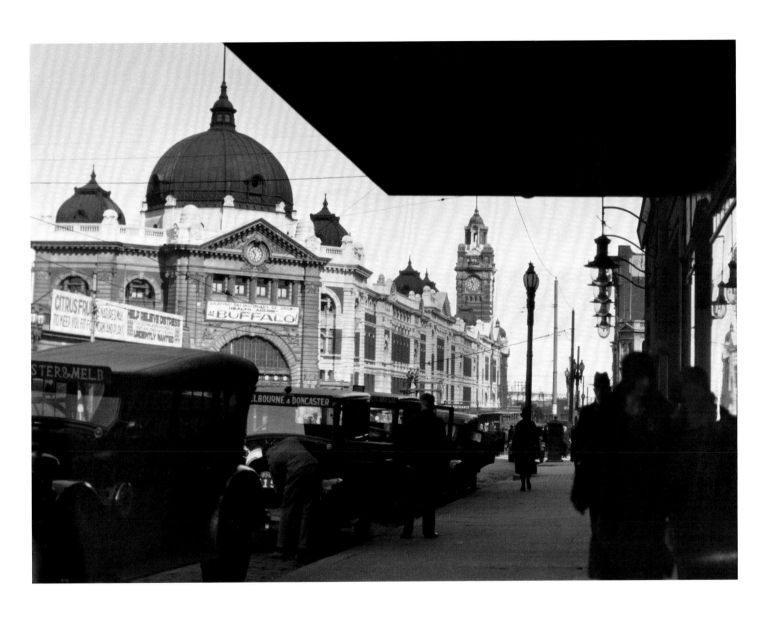

Flinders Street and Railroad Station, Melbourne, 1930

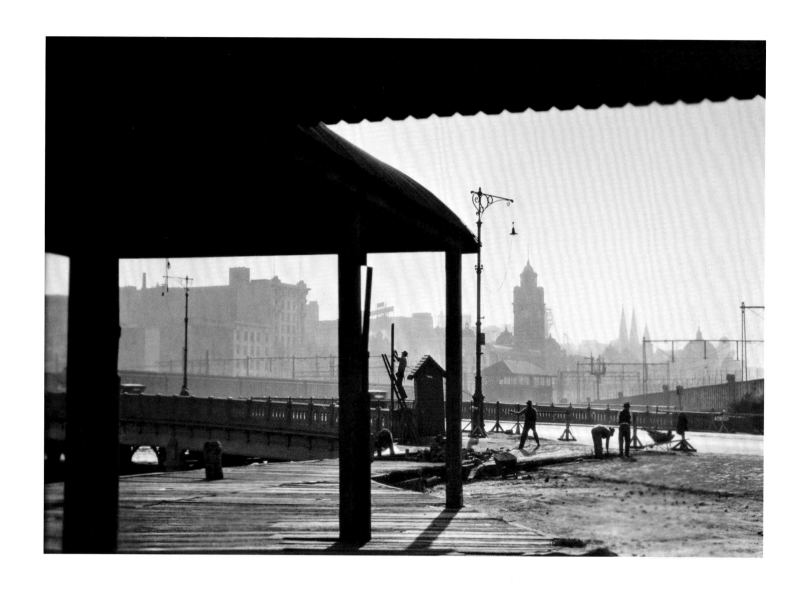

By the Yarra Rver, Melbourne, 1930

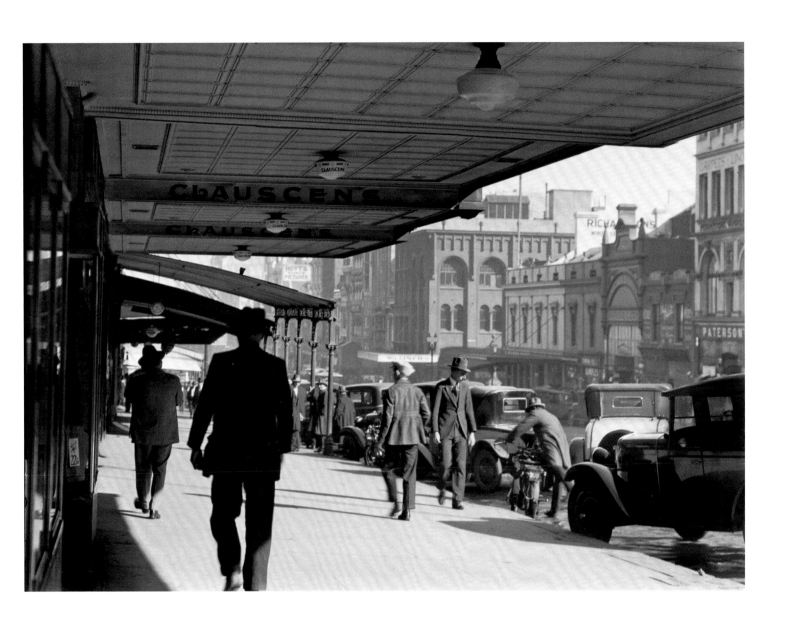

Collins Street, Medical Quarter, Melbourne, 1930

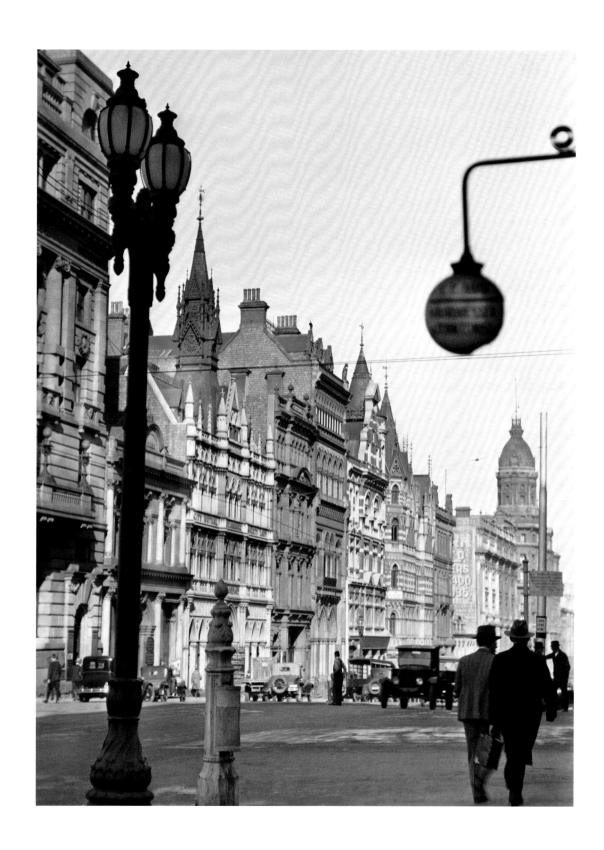

Old Fleet and Rialto Buildings on Collins Street, Melbourne, 1930

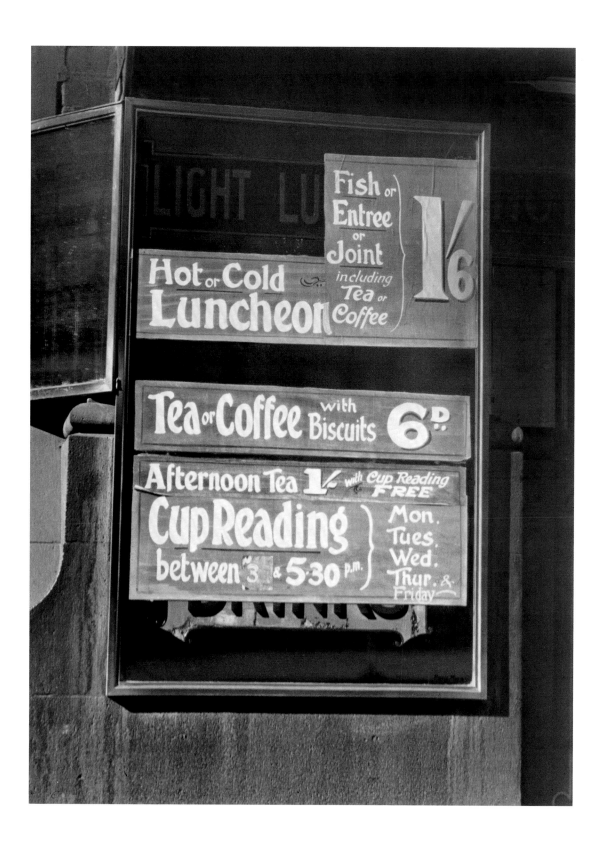

Tea cup reading, Melbourne, 1930

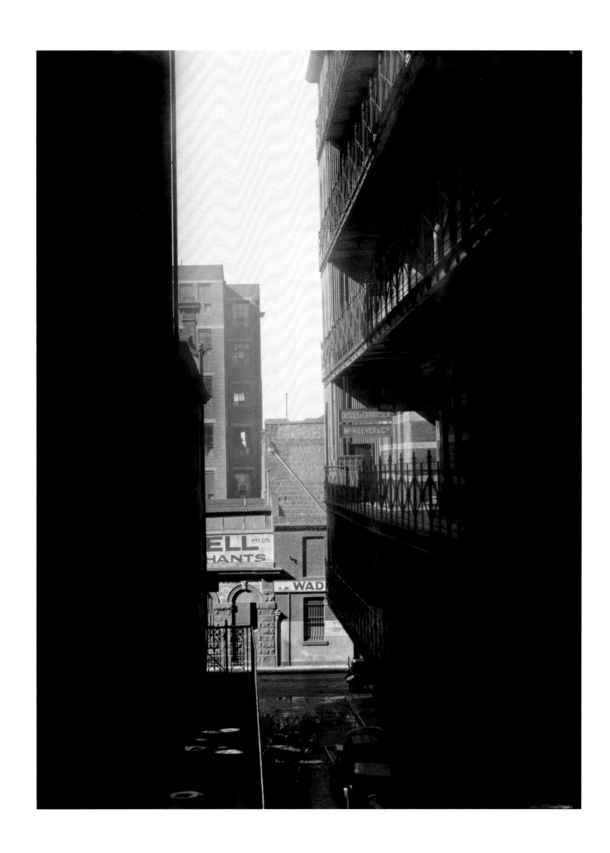

Alleyway, Melbourne, 1930

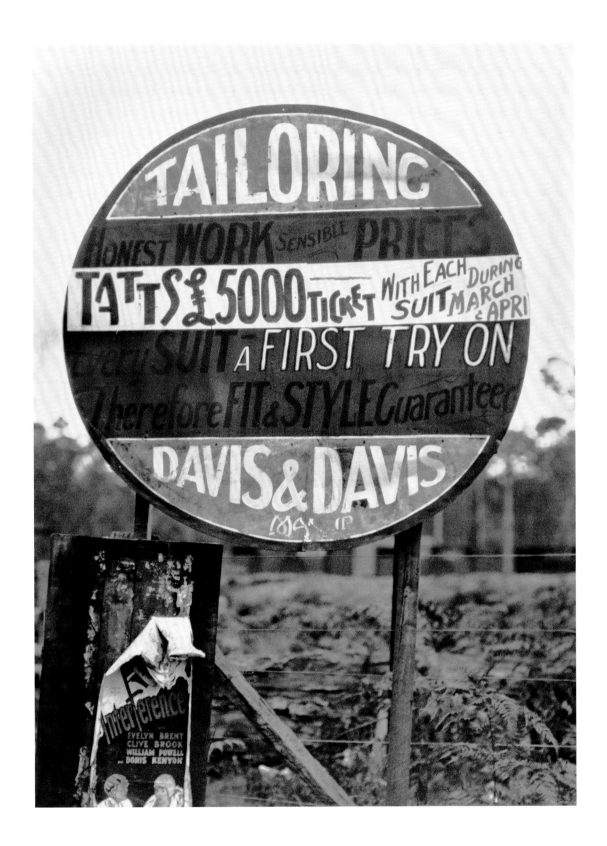

Tailor's advertisement giving away Tattersall tickets, 1930

Two swagmen 'humping their bluies', near Moree, New South Wales, 1930

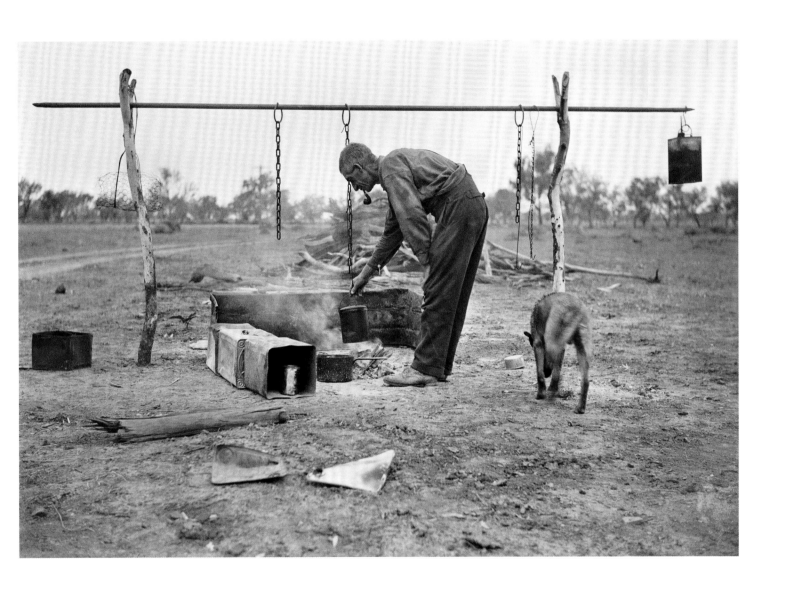

Swagman 'boiling the billy', North West Plains, Moree, New South Wales, 1930

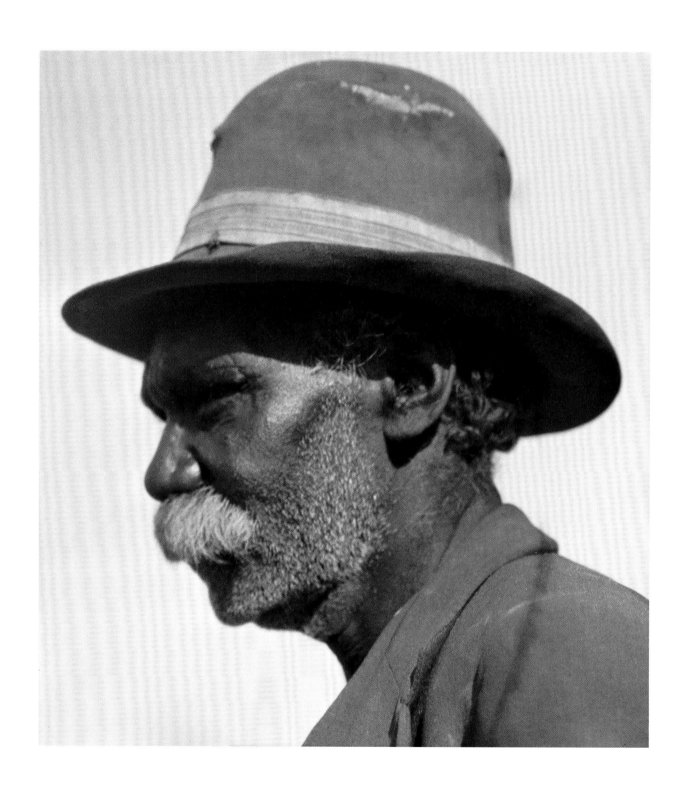

Aboriginal cattleman, Moree, New South Wales, 1930

Marlo, Victoria, 1930

Lilydale, Victoria, 1930

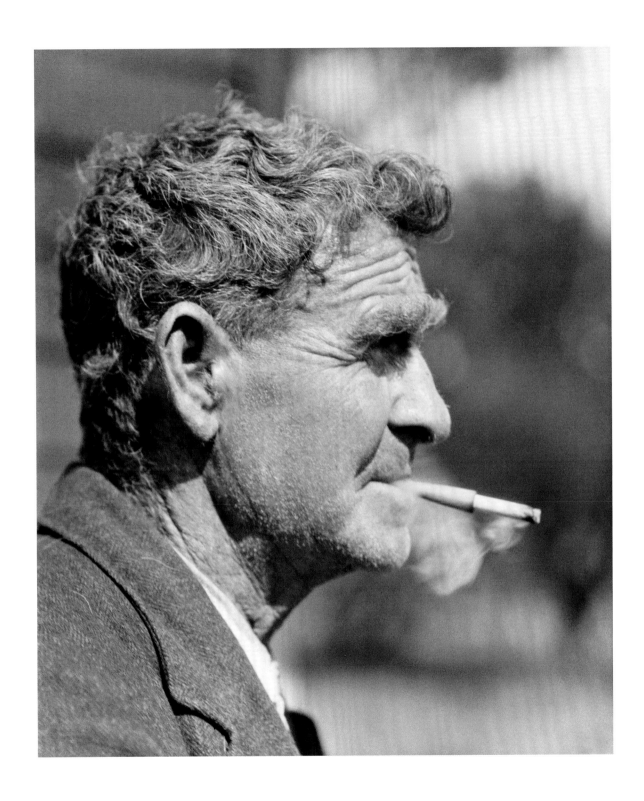

Typical Australian squatter, Victoria, 1930

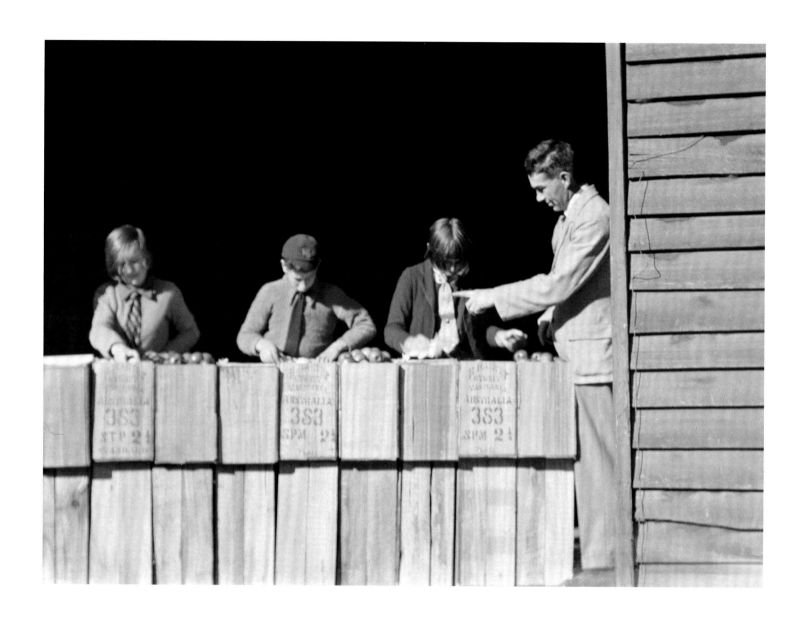

Apple grading at Cygnet, Tasmania, 1930

Applecart, Cygnet, Tasmania, 1930

Hobart Harbour, Tasmania, 1930

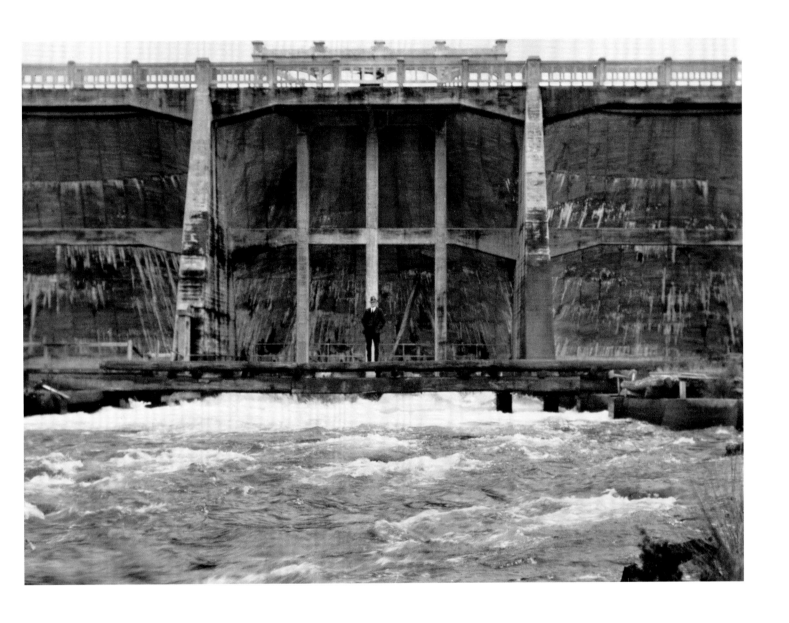

Dam at Great Lake, Miena, Tasmania, 1930

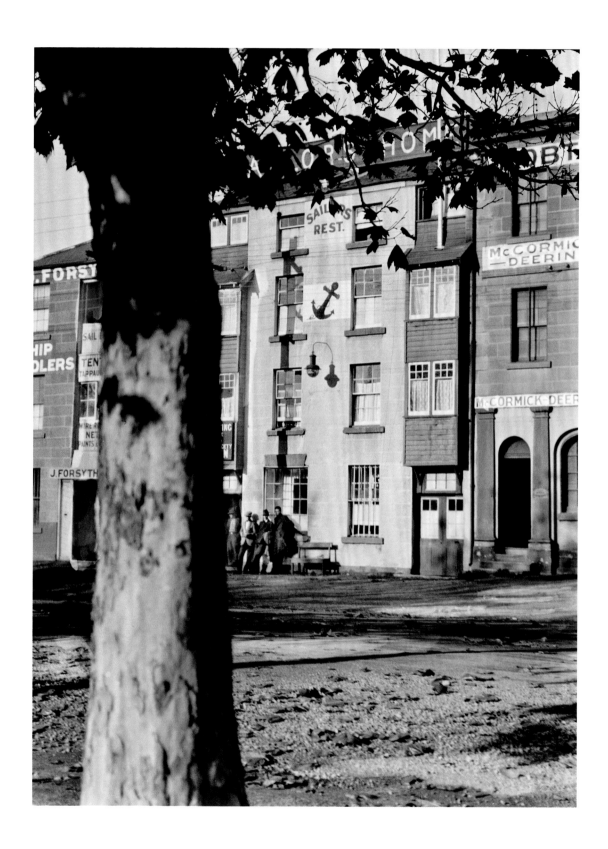

Hobart, Tasmania, 1930

Hobart Harbour, Tasmania, 1930

Palm Beach, Sydney, 1930

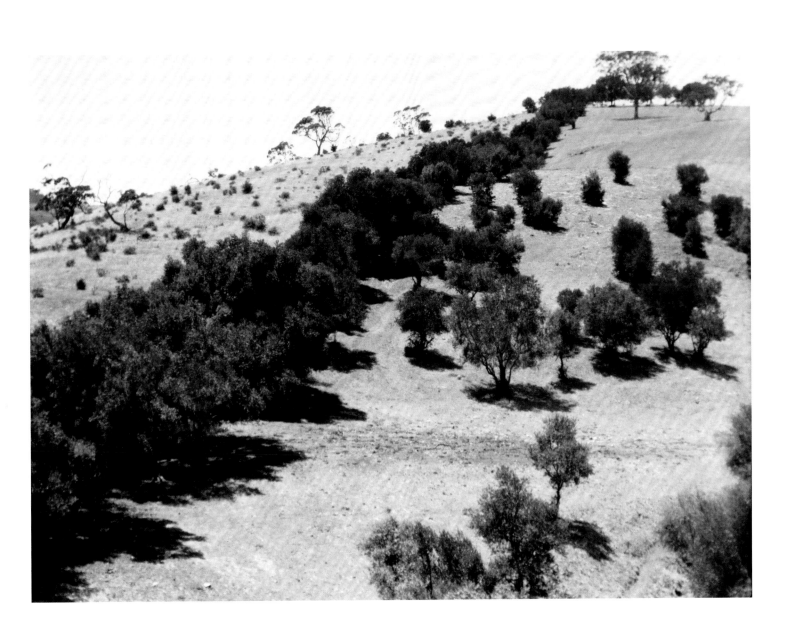

Olive trees, Mount Lofty Ranges, near Adelaide, South Australia, 1930

Penfolds Vineyards, Adelaide, South Australia, 1930

Coopers' Yard, Penfolds, Adelaide, South Australia, 1930

Rundle Hotel, Rundle Street, Adelaide, South Australia, 1930

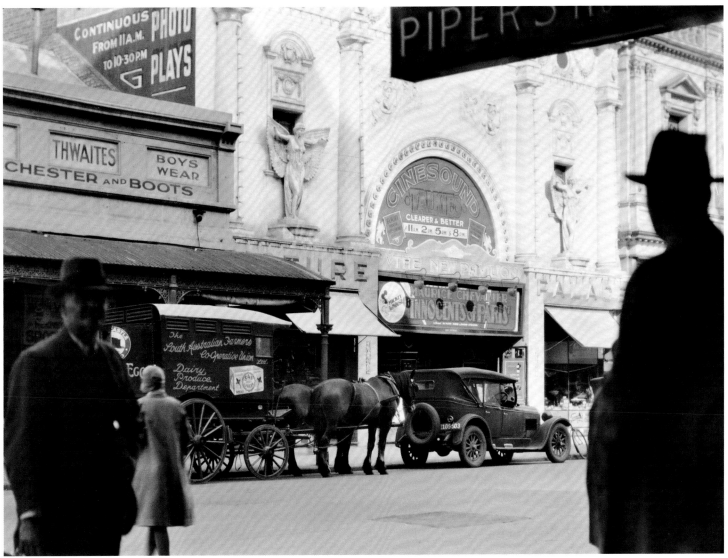

The New Pavilion Theatre, Adelaide, South Australia, 1930

Roadside repair, Adelaide, South Australia, 1930

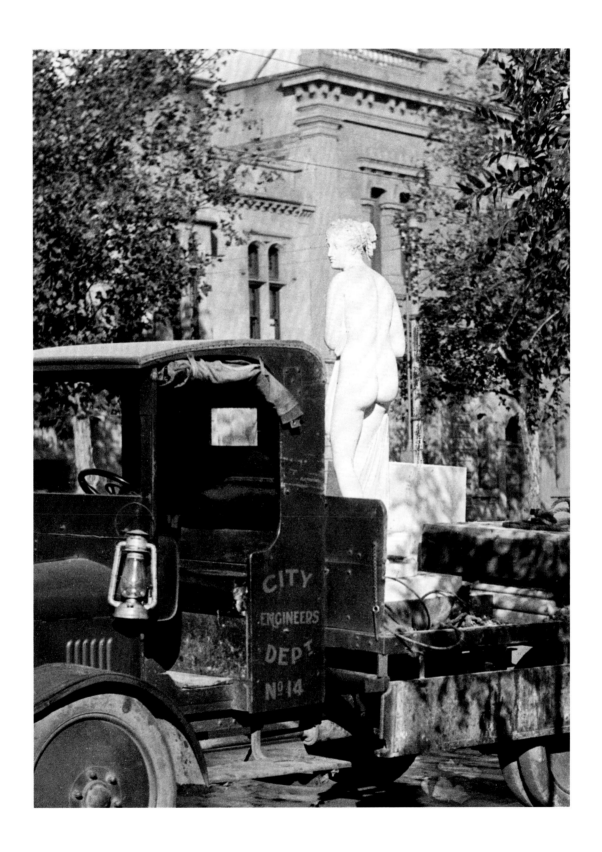

Venus on a truck, Adelaide, South Australia, 1930

Supply train, Trans Australian Line, 1930

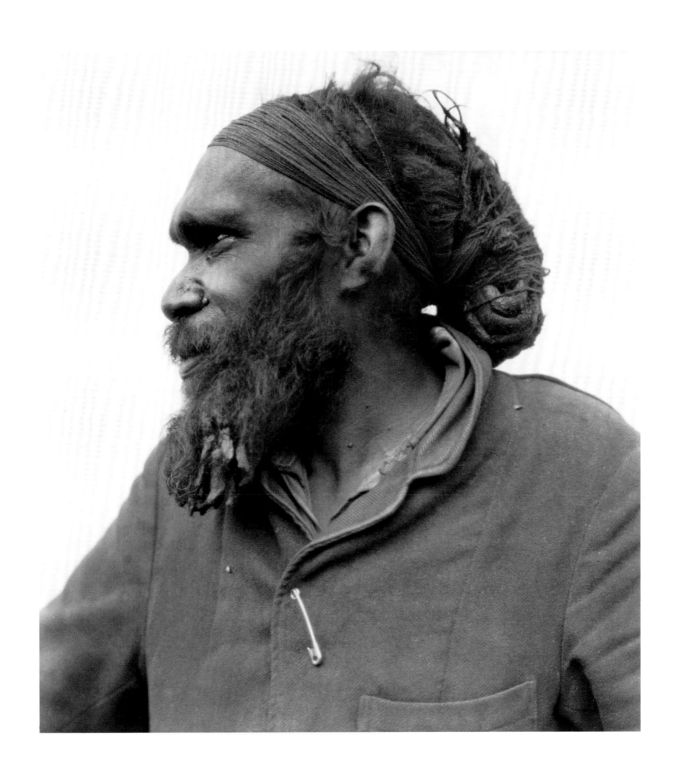

Aboriginal man at Aboriginal camp, 1930

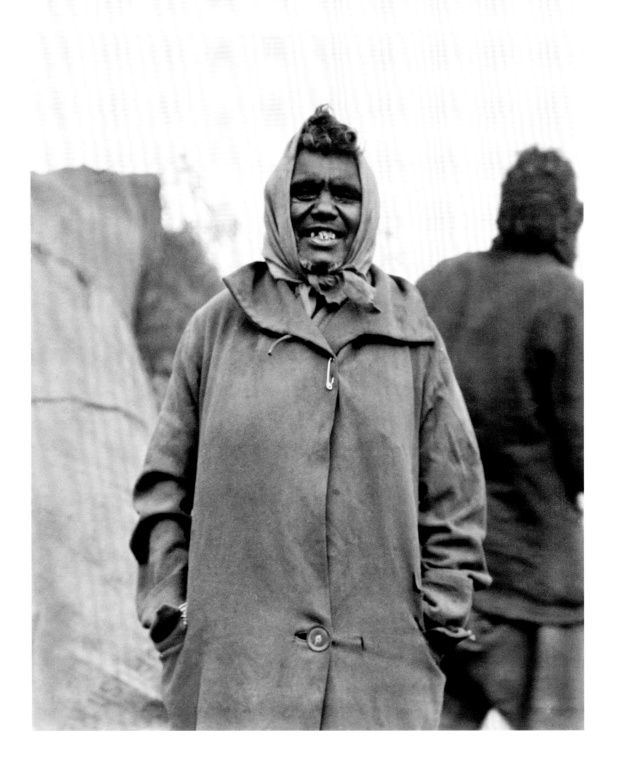

Smiling Aboriginal woman at the Aboriginal camp, 1930

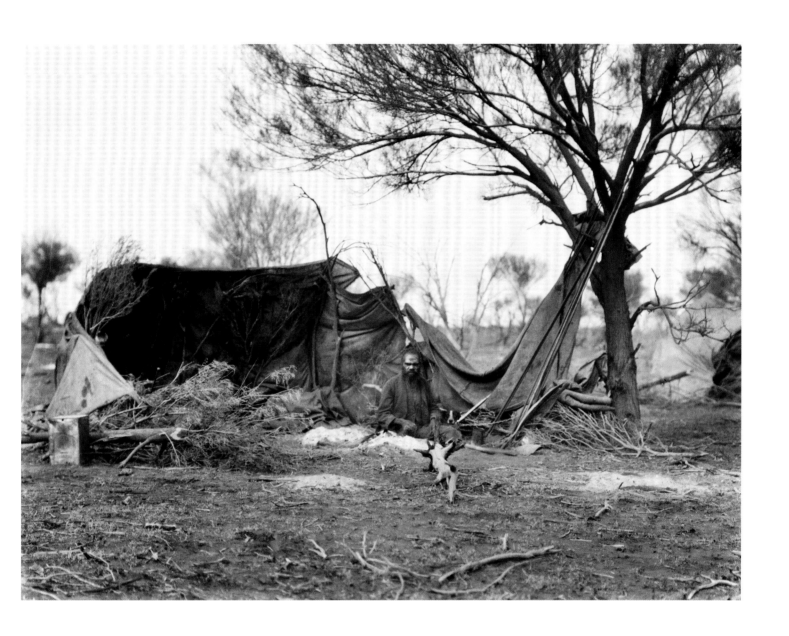

Aboriginal shelter, 1930

Afghan settlement, Marree, South Australia, 1930

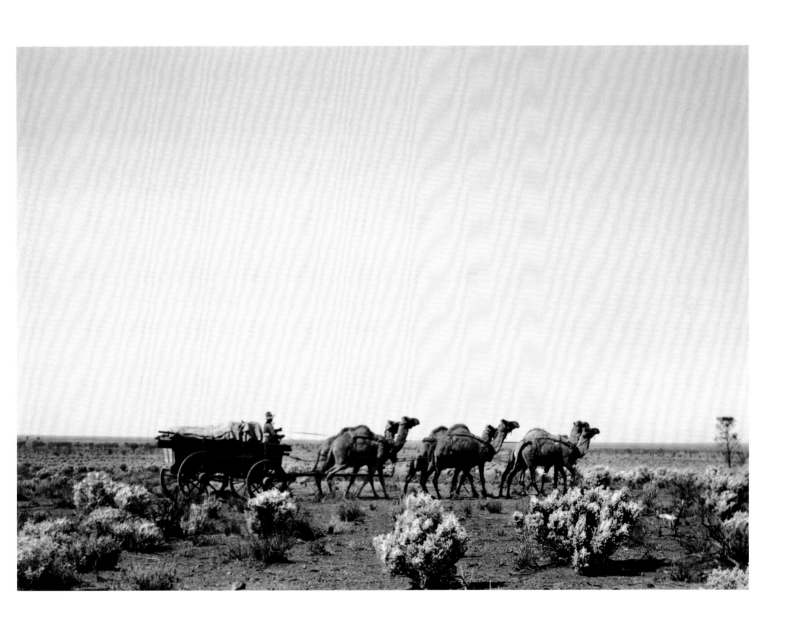

Camel train, South Australia, 1930

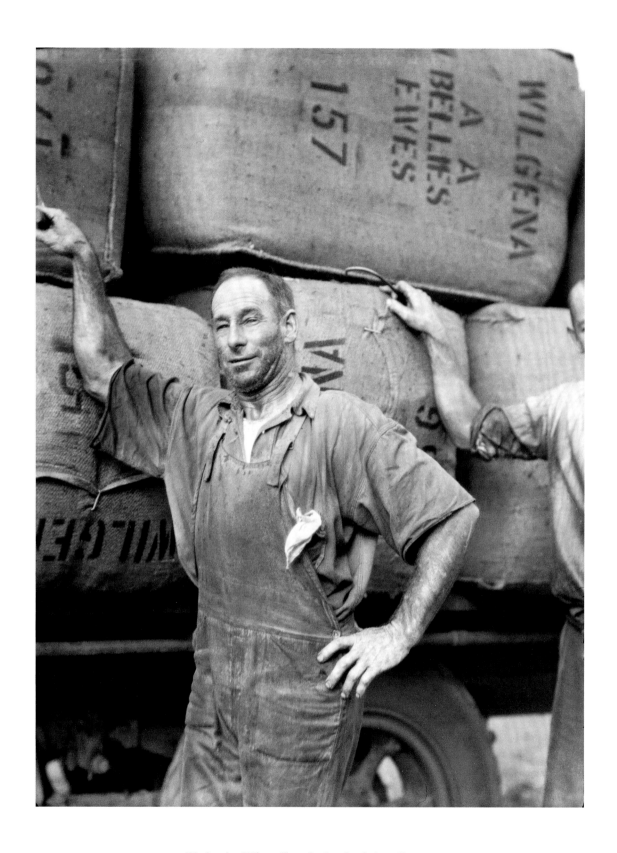

Wool packer, Wilgena Sheep Station, South Australia, 1930

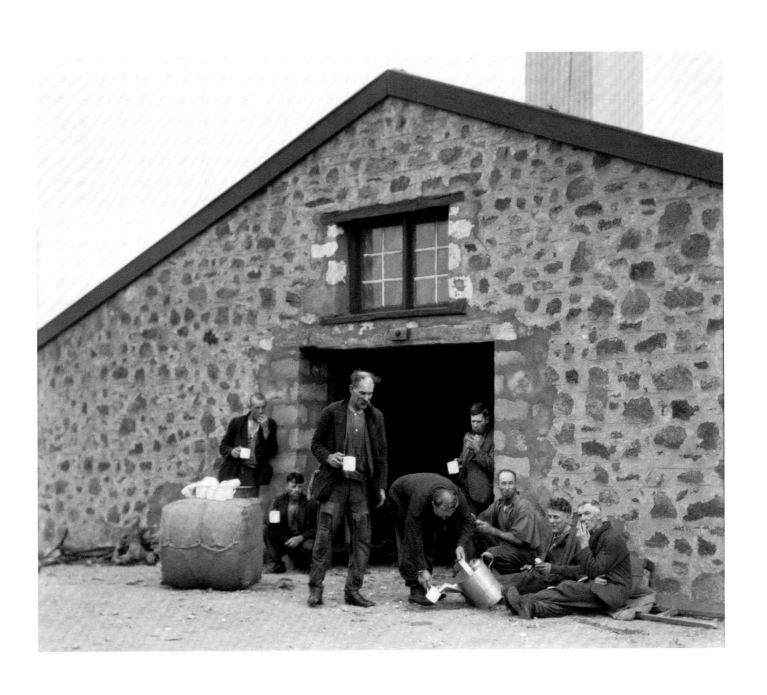

Wool packers having tea, Wilgena Sheep Station, South Australia, 1930

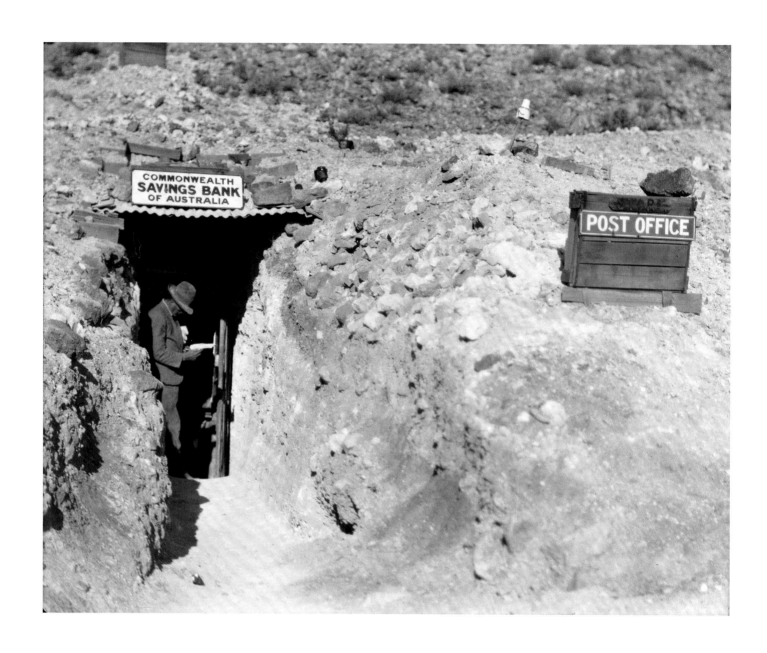

'The Bank' at Coober Pedy Opal Fields, South Australian Outback, 1930

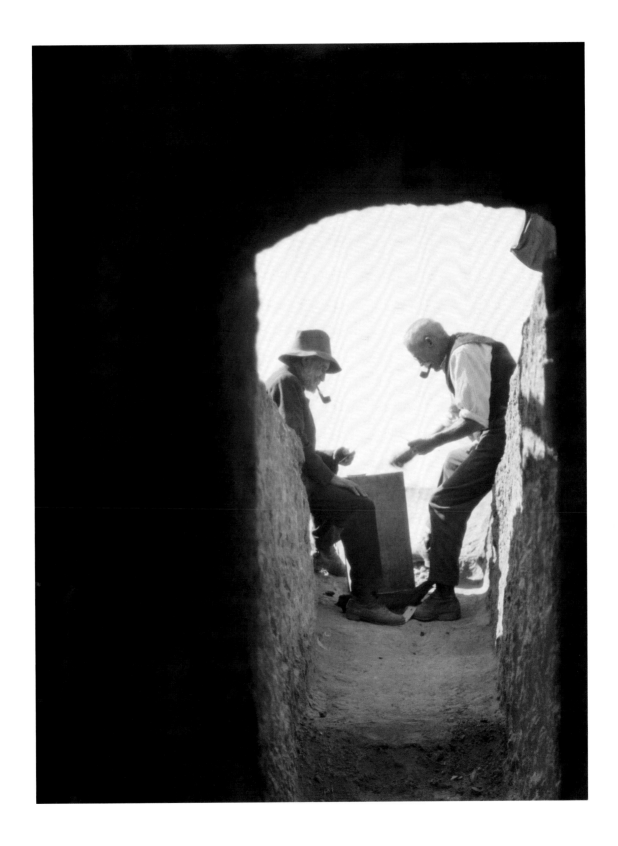

Outside the Dugout, Coober Pedy Opal Fields, South Australian Outback, 1930

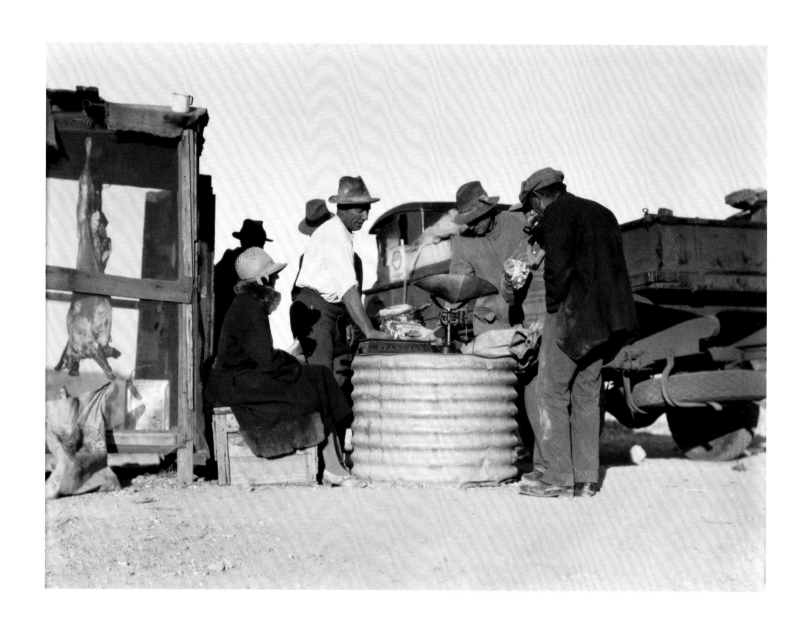

Miss Barrington visits Coober Pedy Opal Fields, South Australian Outback, 1930

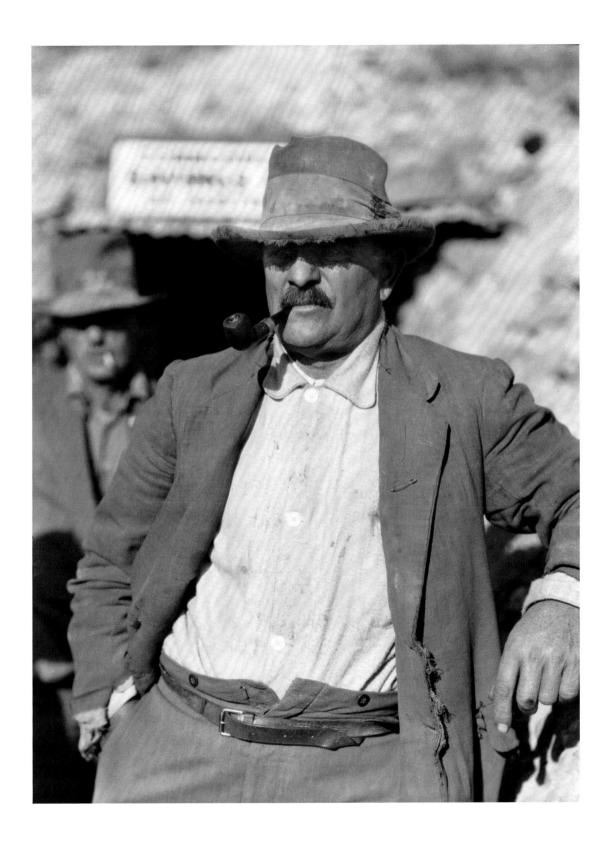

'A Hard Case', Coober Pedy Opal Fields, South Australian Outback, 1930

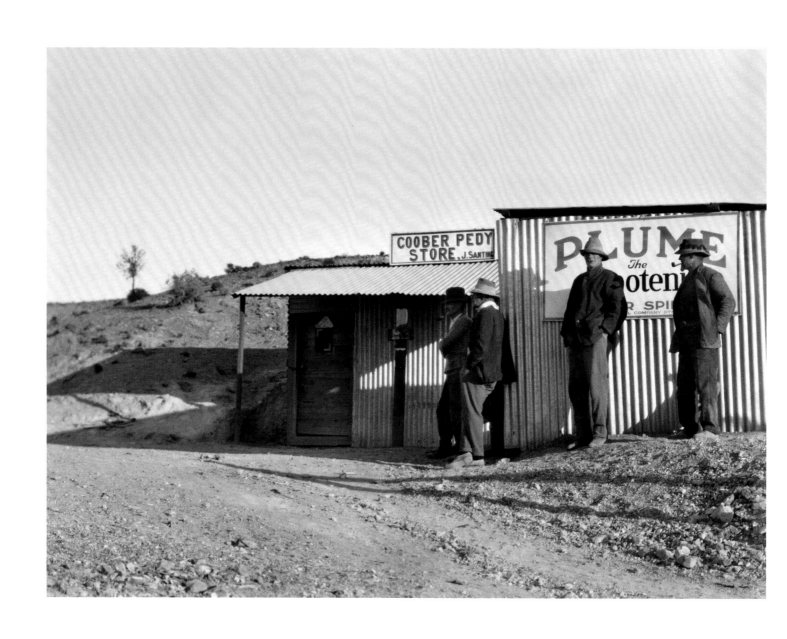

Store, Coober Pedy Opal Fields, South Australian Outback, 1930

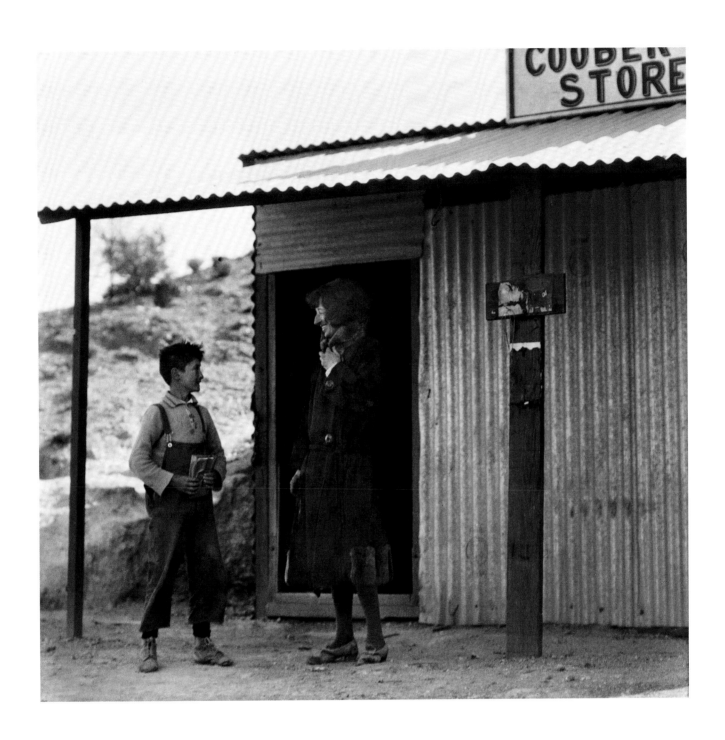

Miss Barrington, Coober Pedy Store, South Australian Outback, 1930

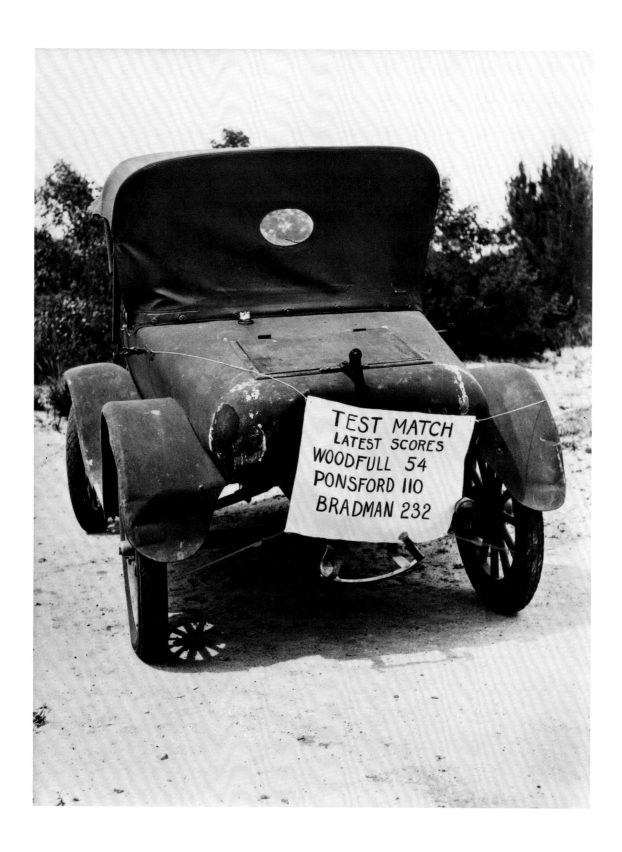

'Test Match Scores', Old Car, Coober Pedy, South Australian Outback, 1930

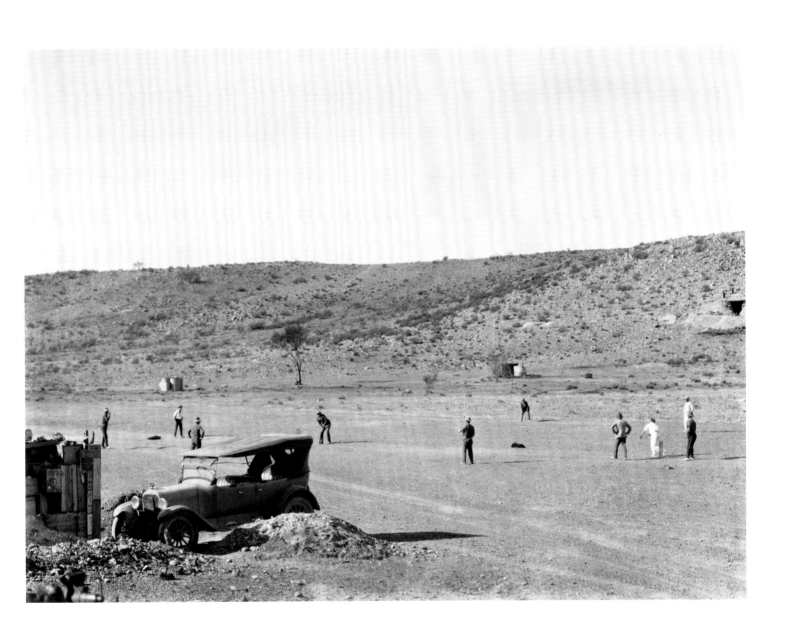

Cricket match, Coober Pedy Opal Fields, South Australian Outback, 1930

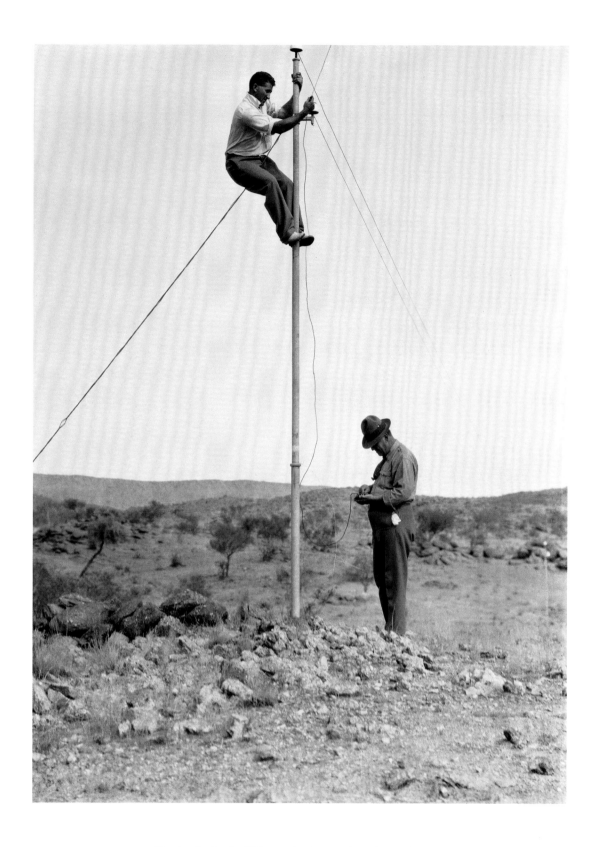

Tapping the Overland Wire at Alice Springs, Central Australia, 1930

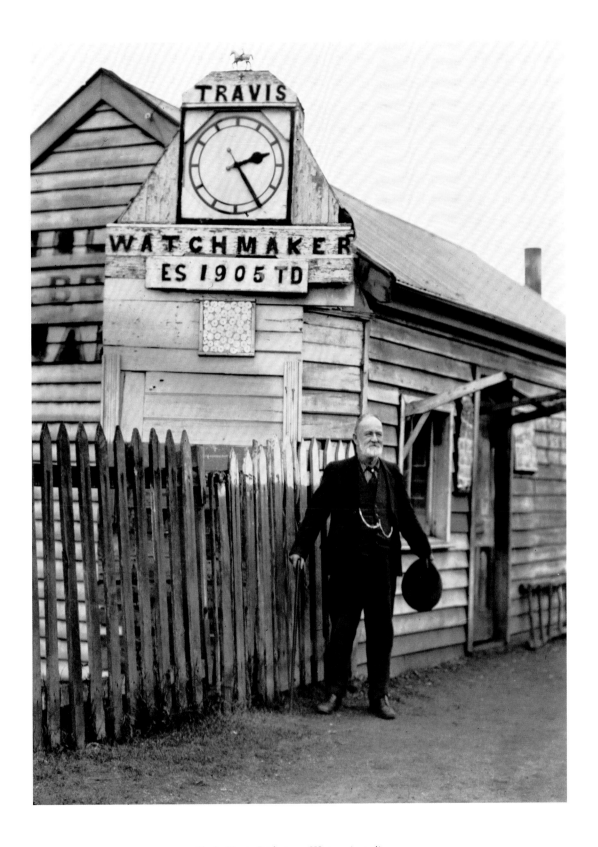

Clocky Travis, Bridgetown, Western Australia, 1930

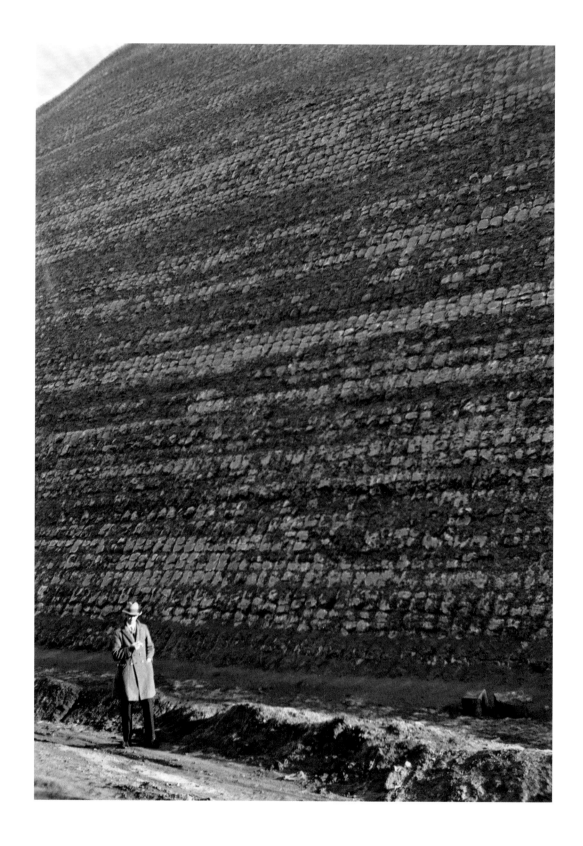

Great Boulder, Kalgoorlie, Western Australia, 1930

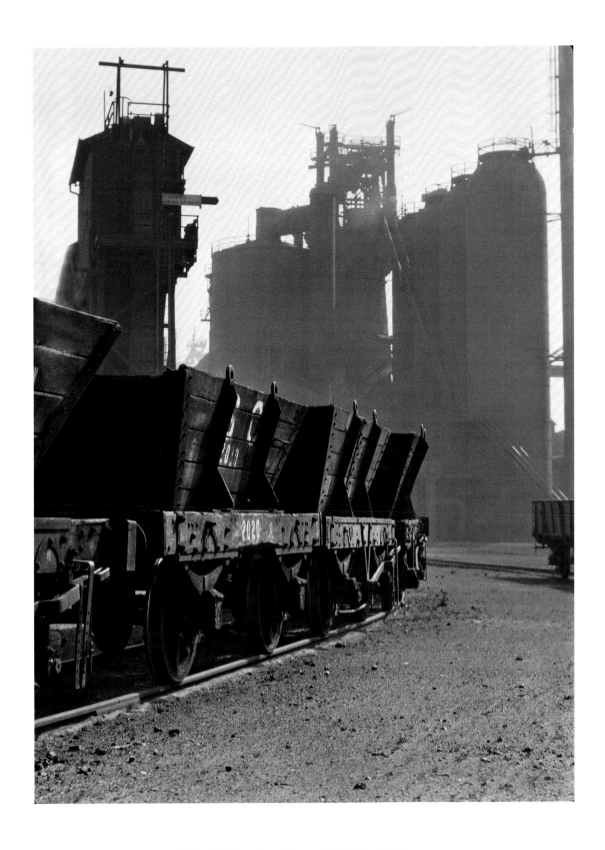

Broken Hill Proprietary, Newcastle, New South Wales, 1930

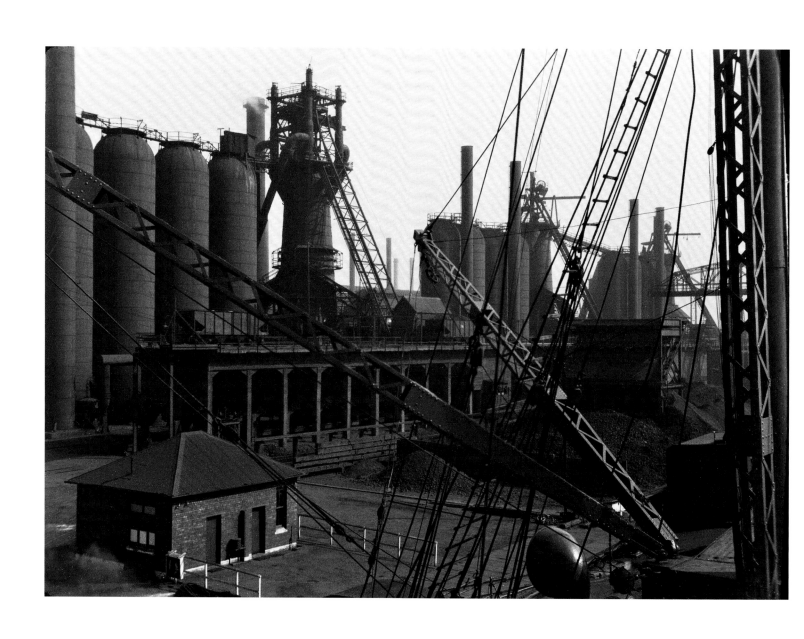

Broken Hill Proprietary, Newcastle, New South Wales, 1930

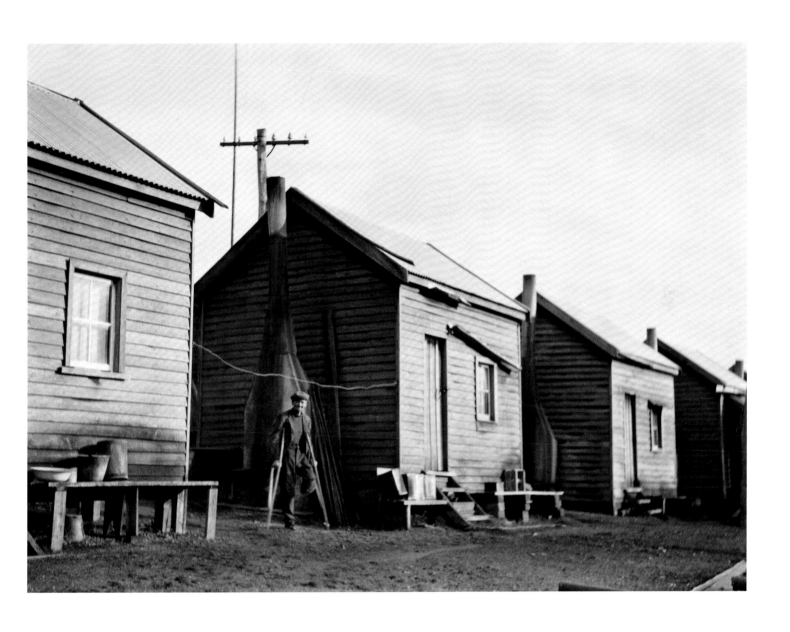

State saw mill bachelors' quarters, Pemberton, Western Australia, 1930

Early morning, Pemberton, Western Australia, 1930

Group settlement, Western Australia, 1930

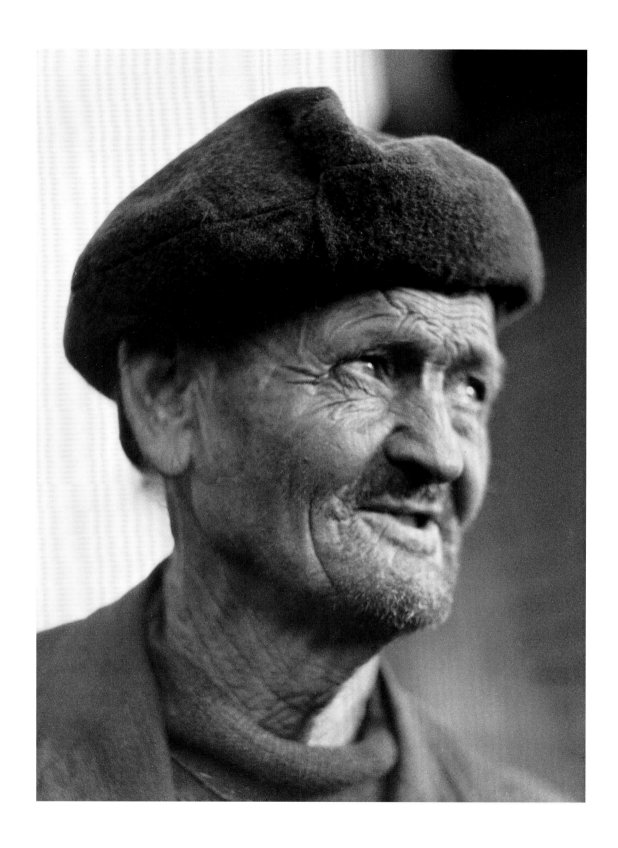

Old timberman, Pemberton, Western Australia, 1930

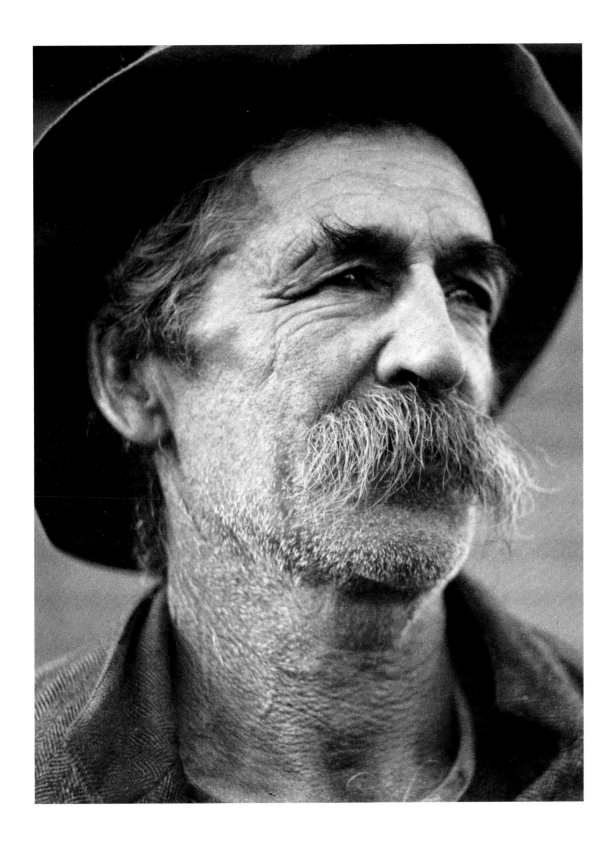

Mr Brown, sheep farmer, Tasmania, 1930

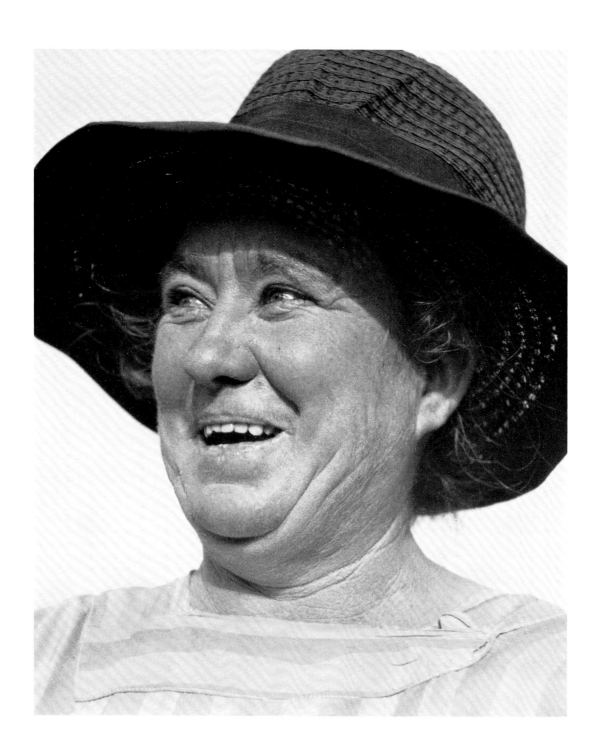

Mrs Annie Brown, sheep farmer, Tasmania, 1930

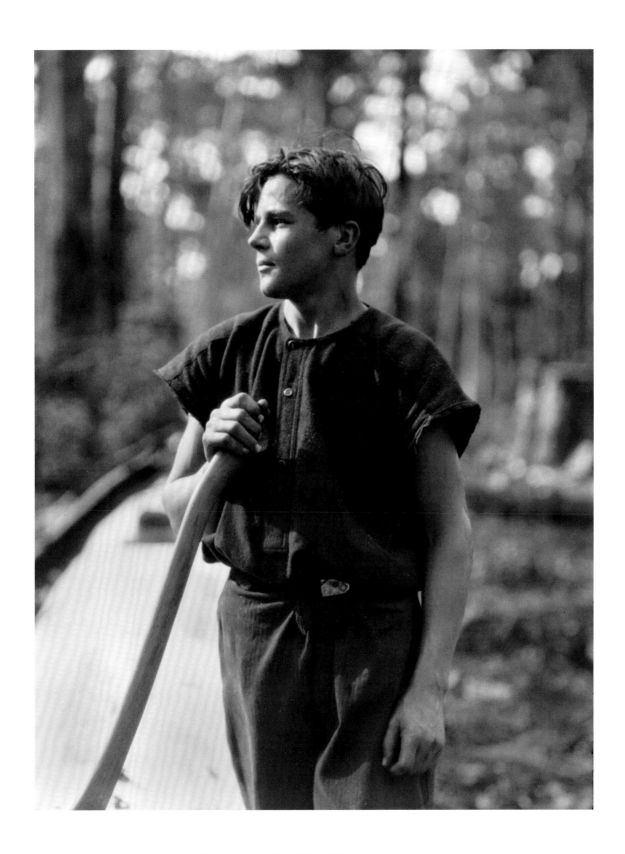

Young axeman in Kauri Forest, Western Australia, 1930

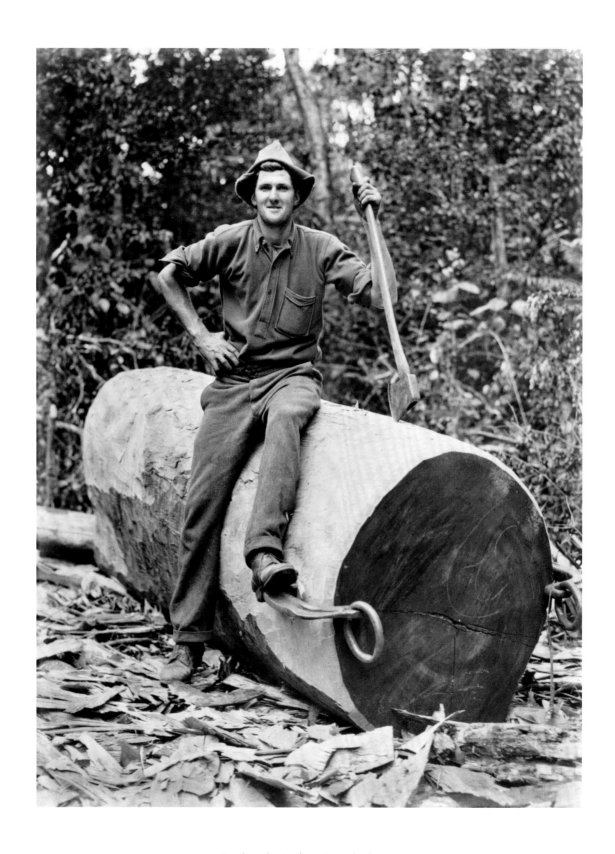

Lumberjack, Northern Queensland, 1930

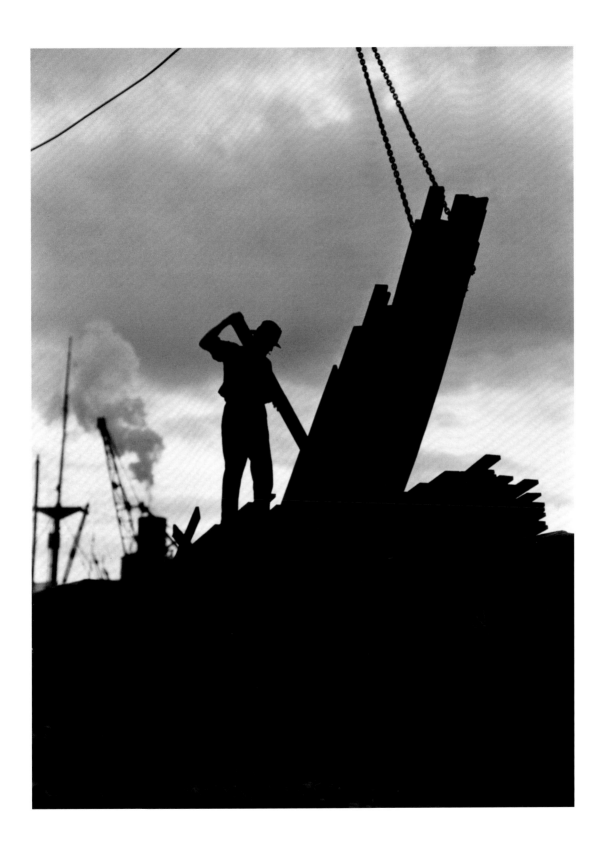

Timber, Bunbury, Western Australia, 1930

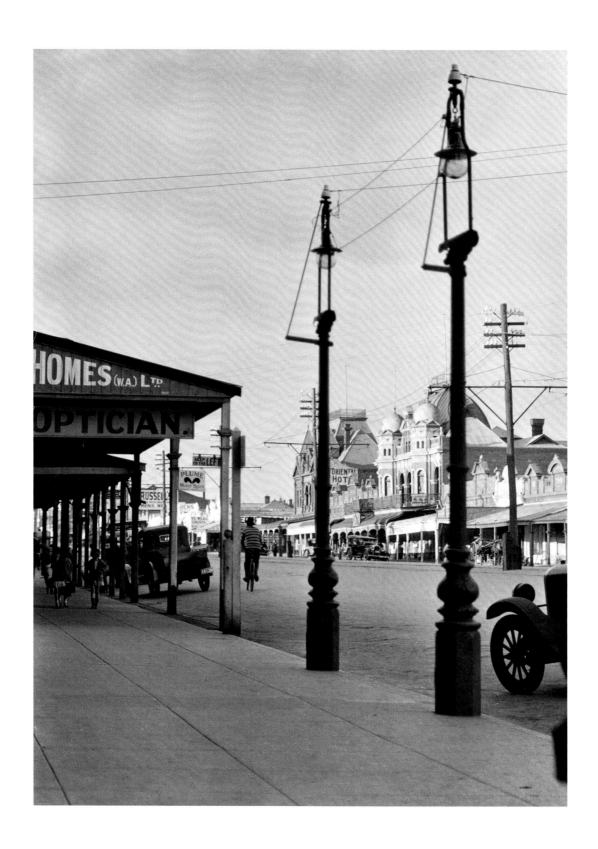

Main Street, Kalgoorlie, Western Australia, 1930

Two figures, Hermannsburg, Central Australia, 1930

Pastor Albrecht and his family, Hermannsburg Lutheran Mission Station, Central Australia, 1930

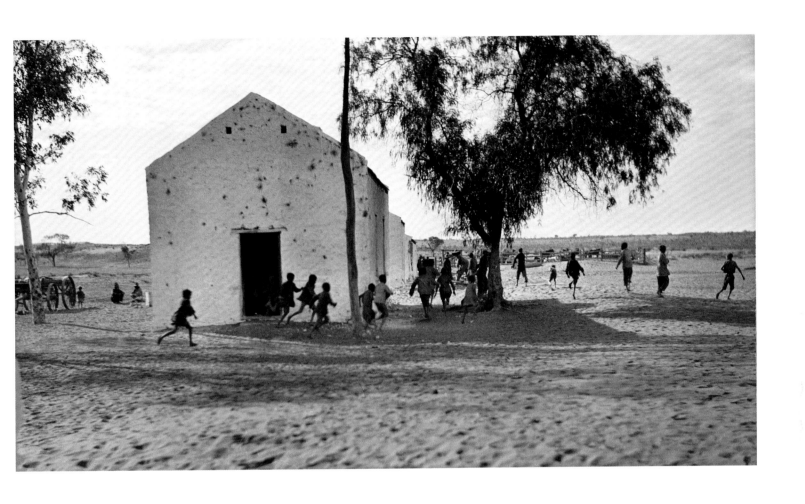

Mission School, New Norica, Western Australia, 1930

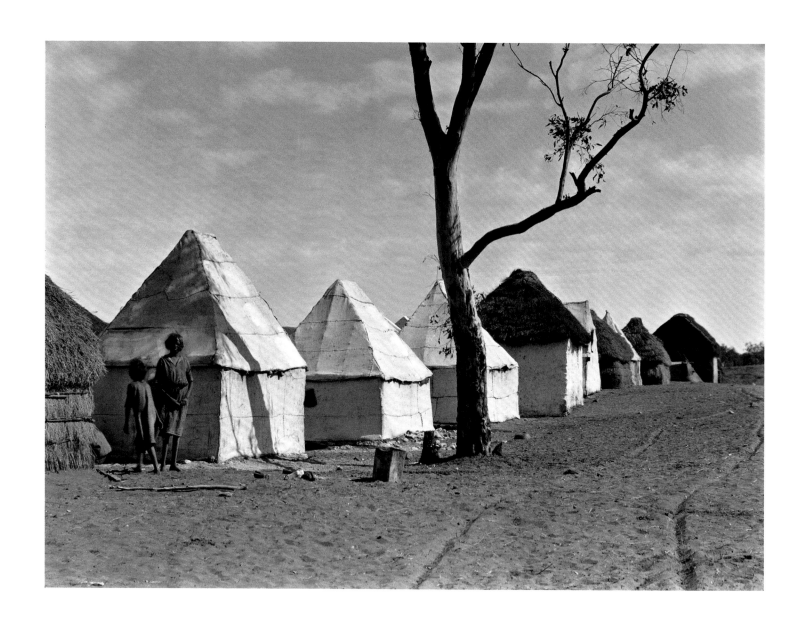

Aboriginal huts, Hermannsburg Lutheran Mission Station, Central Australia, 1930

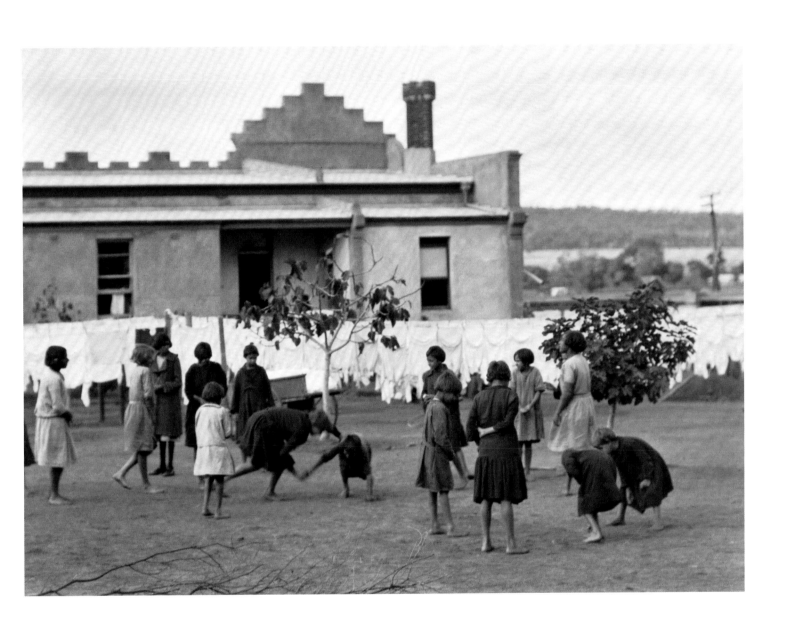

Aboriginal children's school, New Norcia Mission, 1930

Multiracial girl at the Aboriginal Mission school, New Norcia, 1930

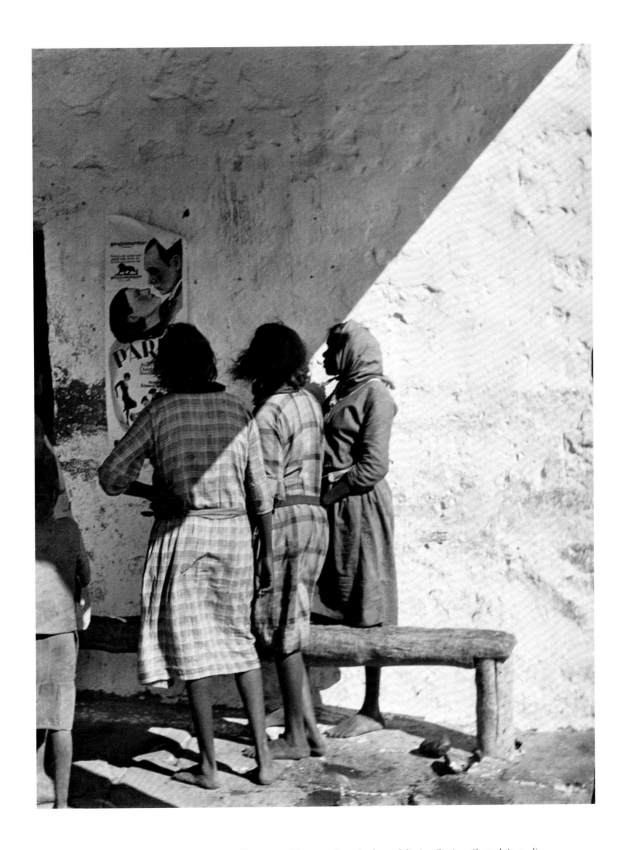

Aboriginal women looking at European film poster, Hermannsburg Lutheran Mission Station, Central Australia, 1930

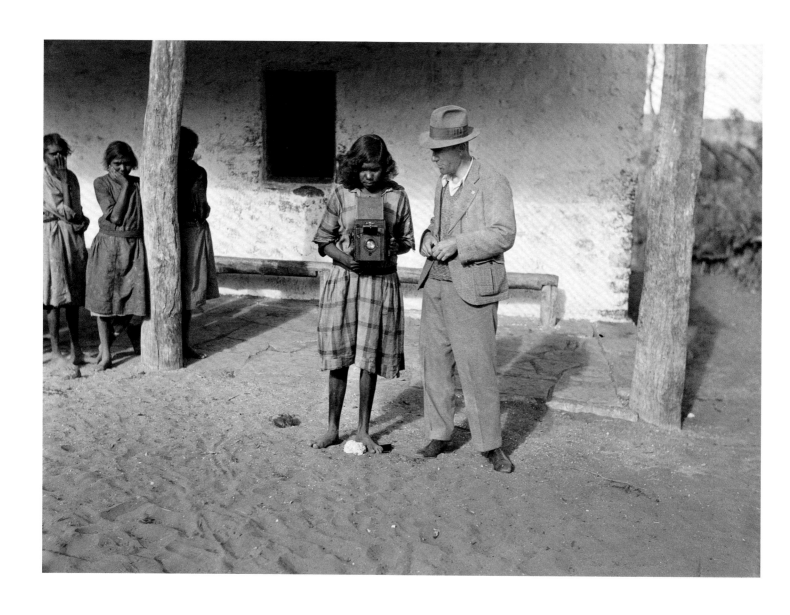

Aboriginal woman inspects E.O. Hoppé's camera, Hermannsburg Lutheran Mission Station, Central Australia, 1930

Nun with school girls, New Norcia Mission, 1930

Mrs Taylor, South Australia, 1930

Mounted constable Eric MacNab, Darwin, Northern Territory, 1930

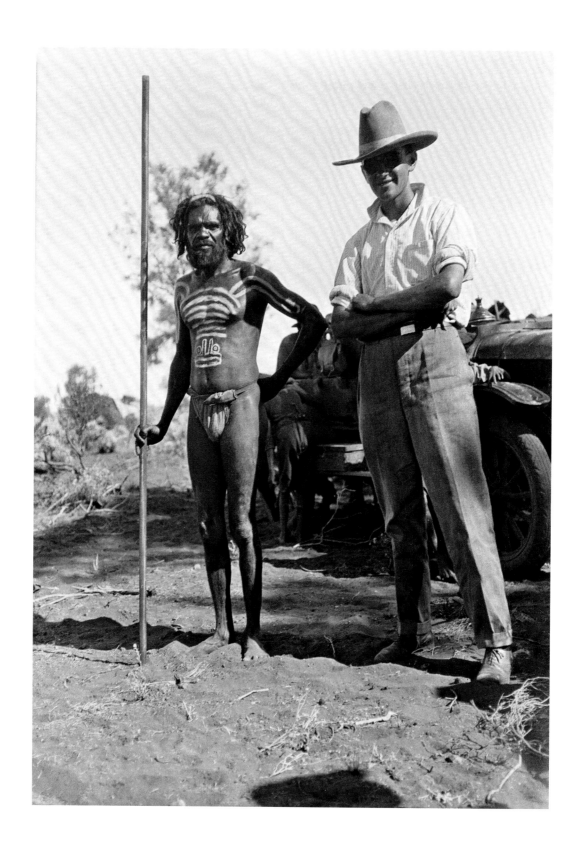

Aboriginal chief with westernised trader, Central Australia, 1930

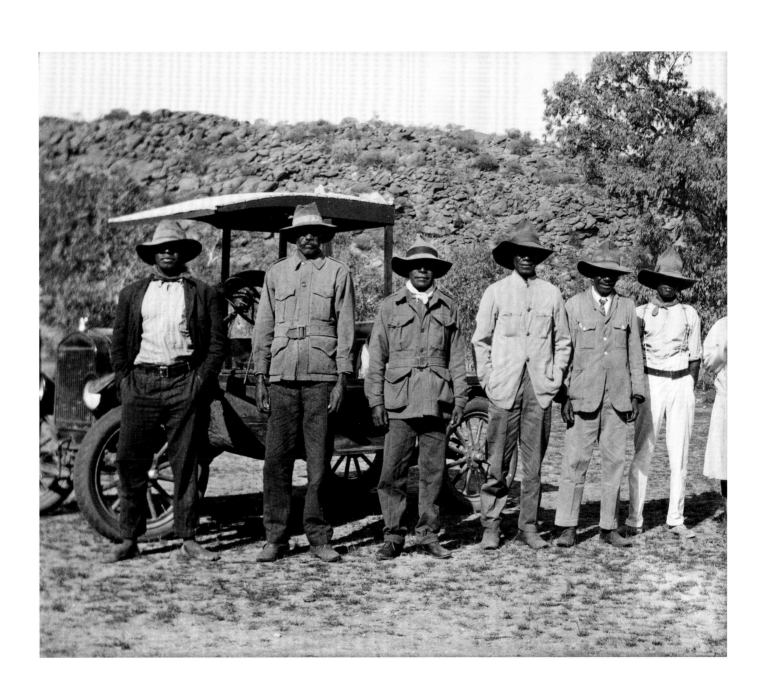

Aboriginal police trackers, Central Australia, 1930

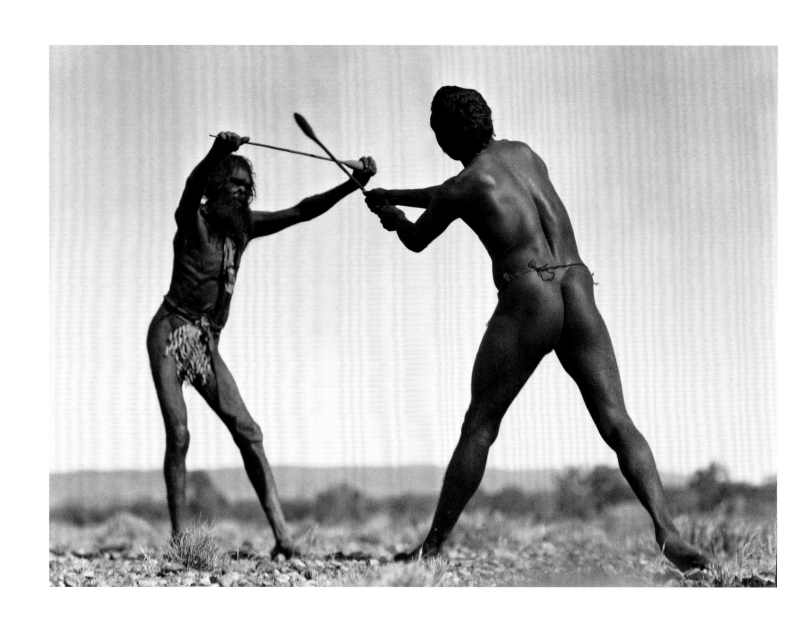

Aborigines fighting, Central Australia, 1930

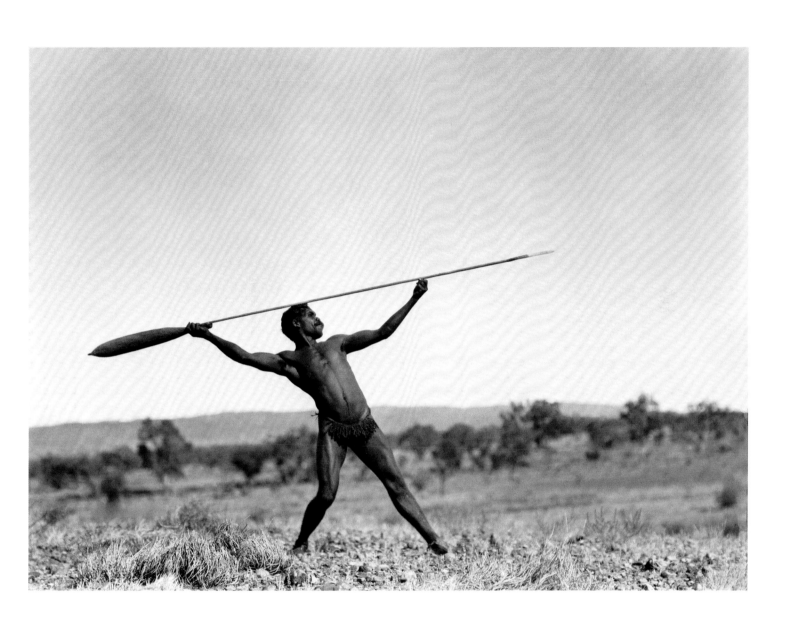

Aboriginal spear thrower, Central Australia, 1930

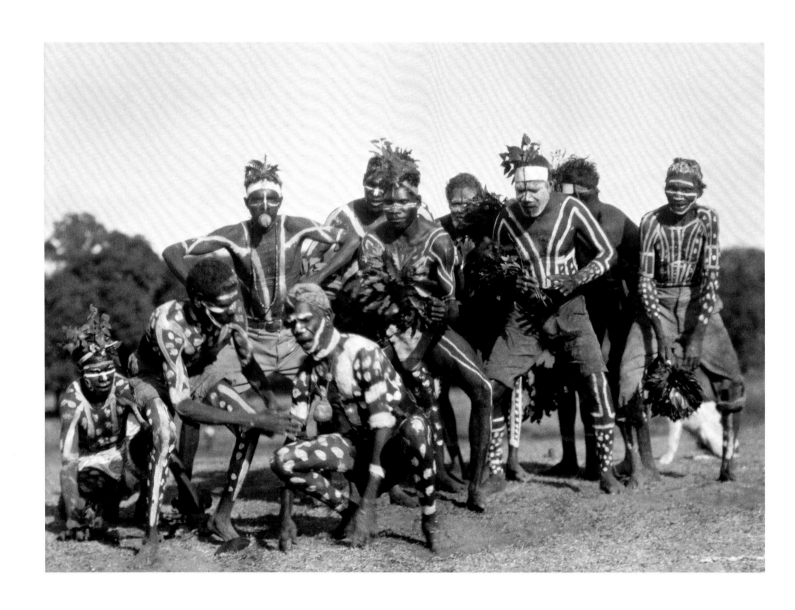

Aborigines performing the Kangaroo Dance, Hermannsburg Lutheran Mission Station, Central Australia, 1930

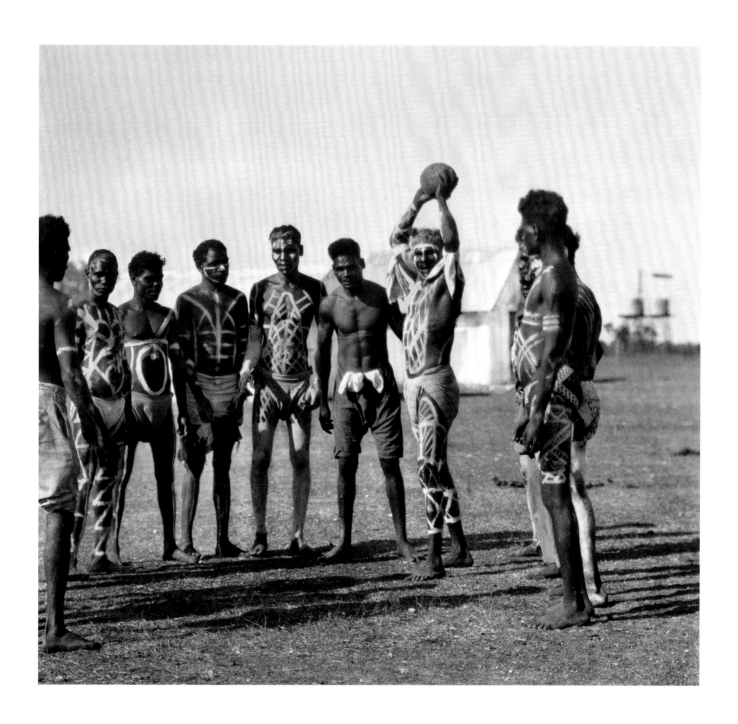

Aborigines playing football at the Hermannsburg Lutheran Mission Station, Central Australia, 1930

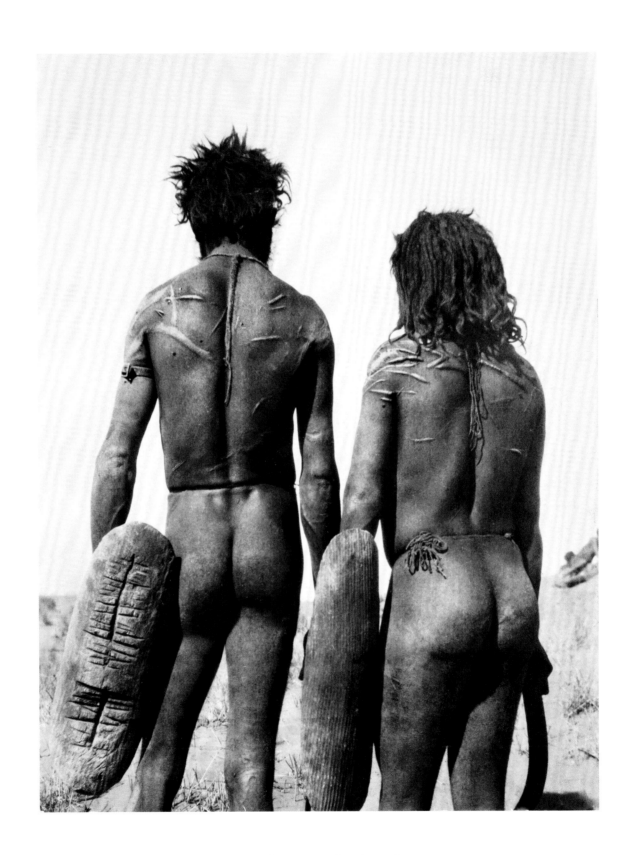

Aborigines with scarification, Central Australia, 1930

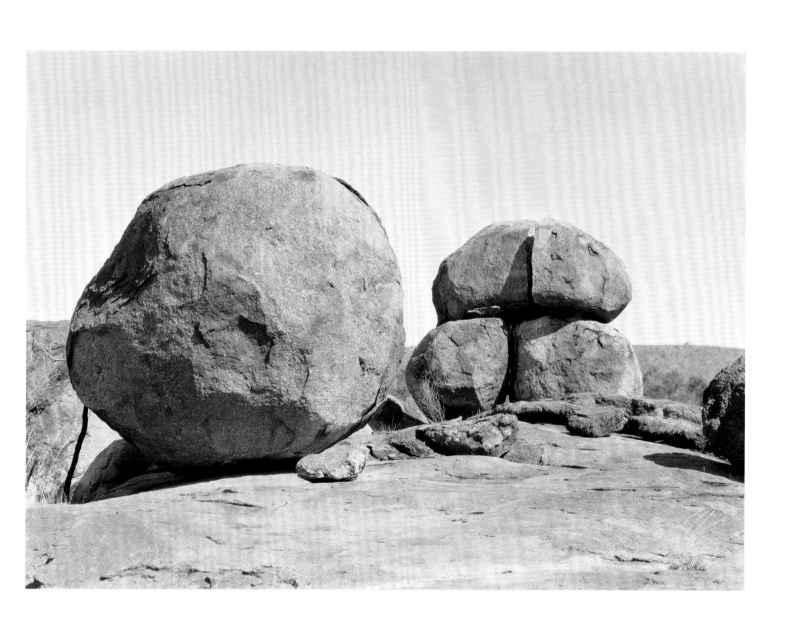

Devil's Marbles, Mount Stuart, Central Australia, 1930

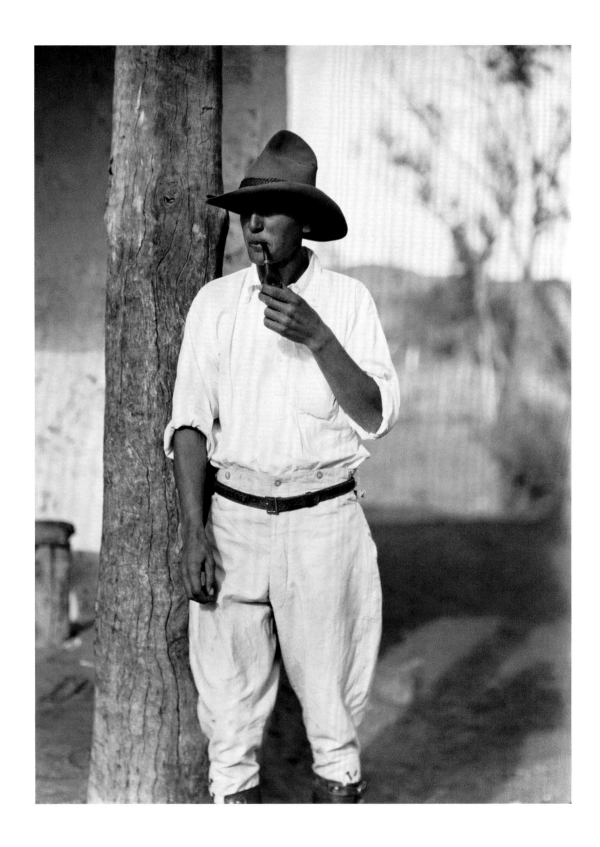

Young German dingo hunter, Hermannsburg Lutheran Mission Station, Central Australia, 1930

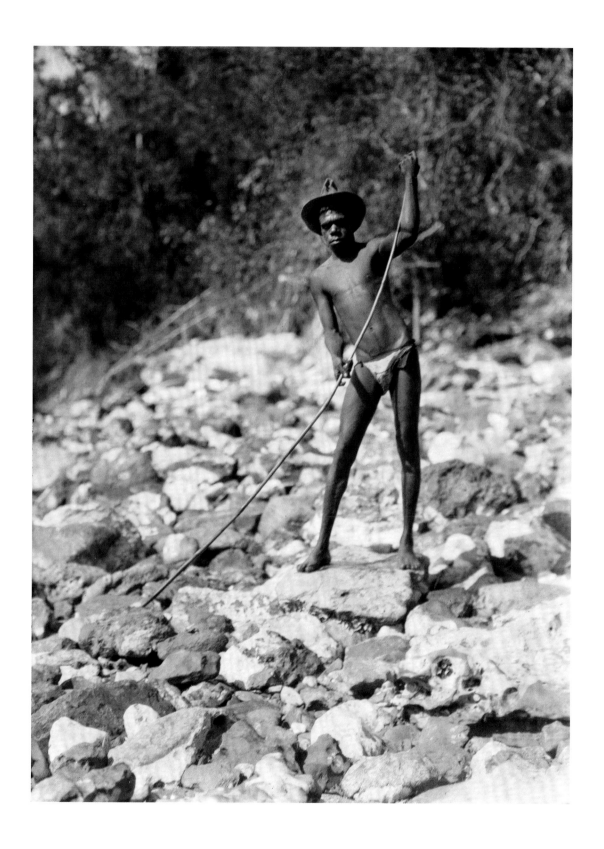

Young Aborigine with fishing spear, Albatross Bay, Queensland, 1930

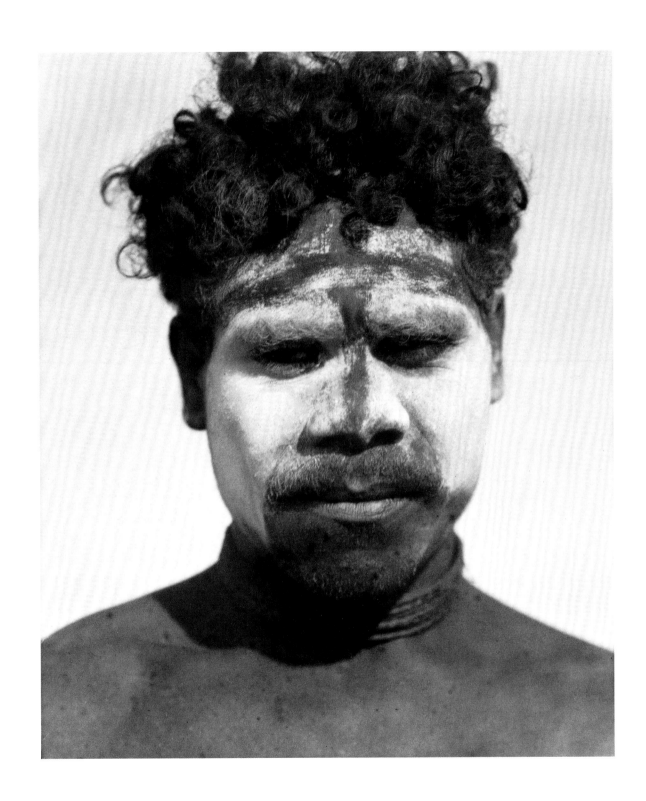

Aborigine in full war paint, Central Australia, 1930

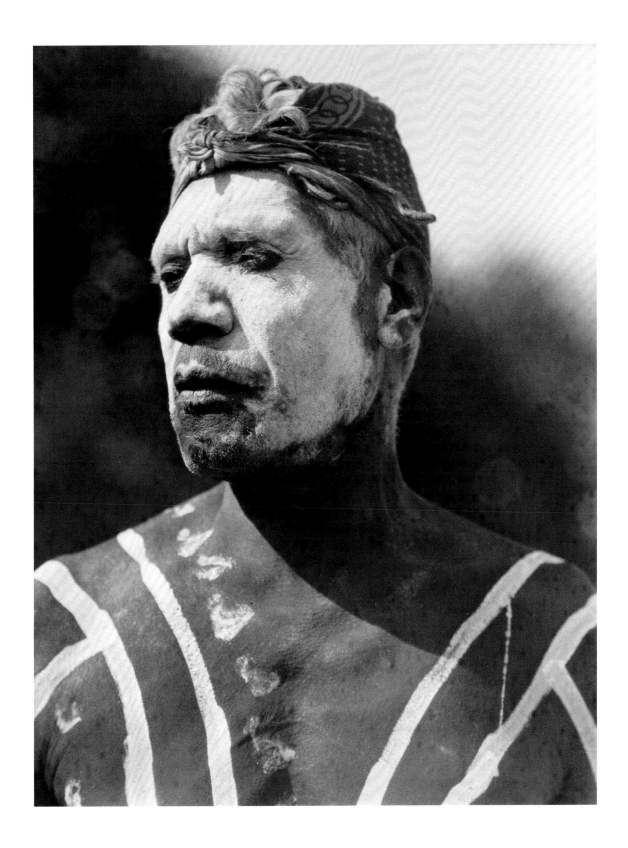

Aborigine painted in ceremonial design, Central Australia, 1930

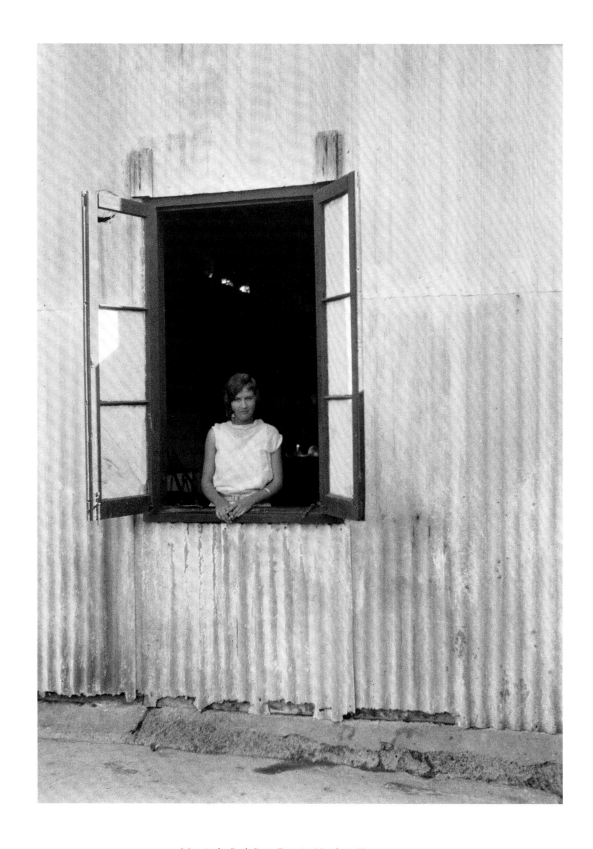

Maggie the Bush Poet, Darwin, Northern Territory, 1930

The Darling Range, Western Australia, 1930

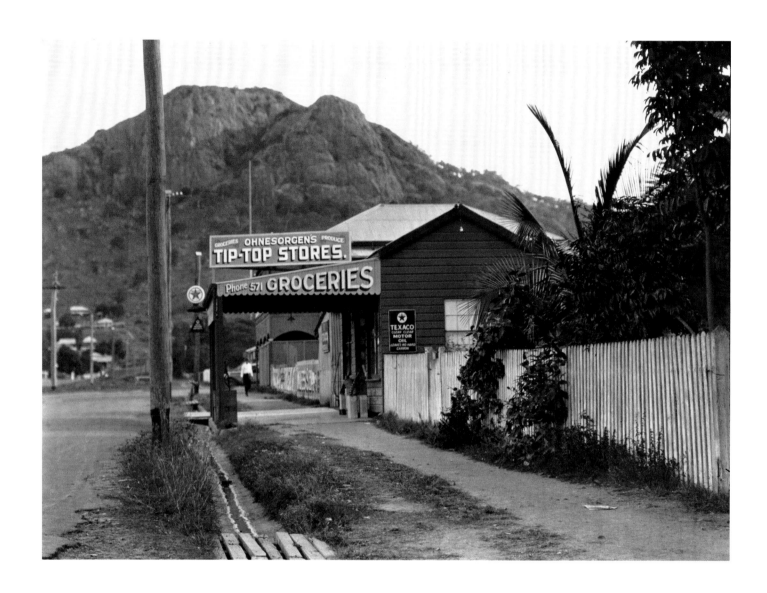

German grocery store, Townsville, Queensland, 1930

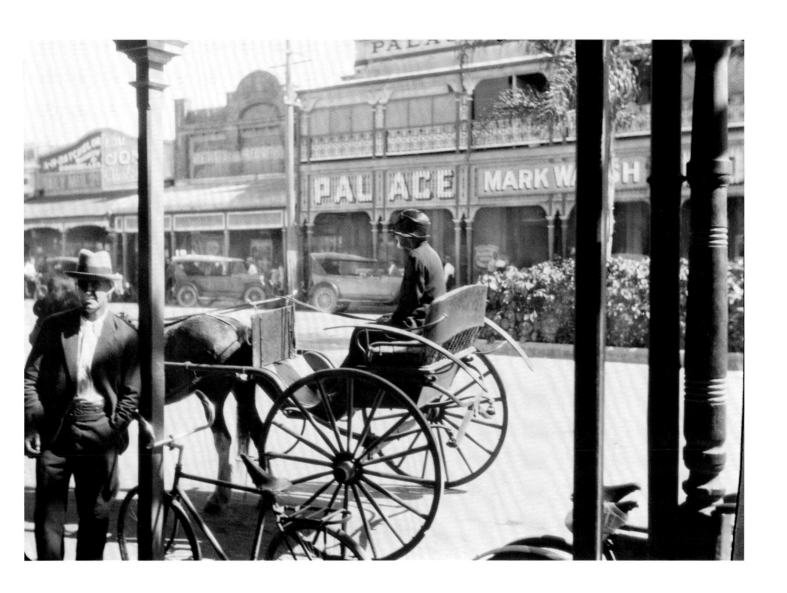

Disappearance of the small town, Townsville, Queensland, 1930

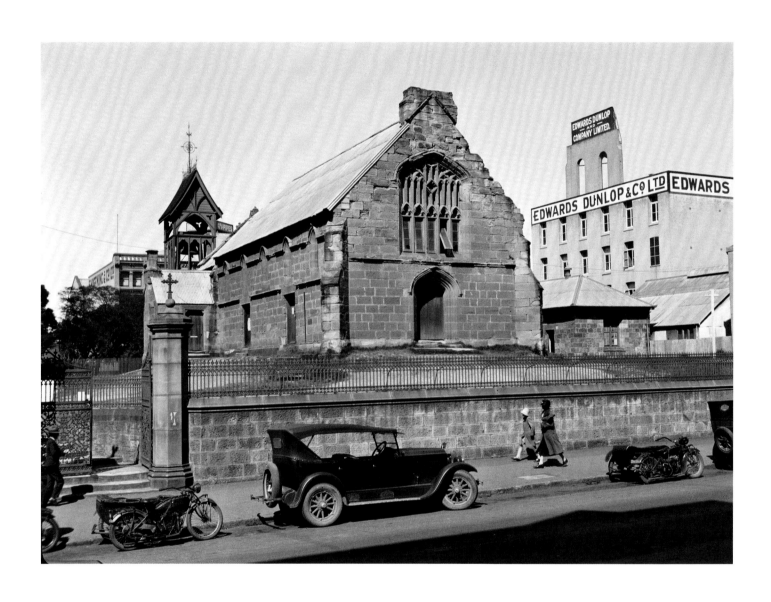

Old Church, Brisbane, Queensland, 1930

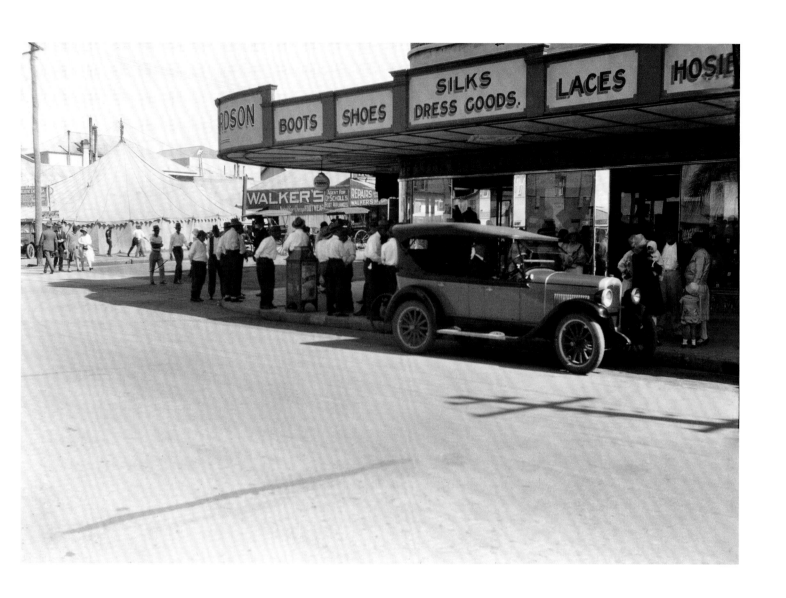

Townsville, Queensland, 1930

Innisfail, Queensland, 1930

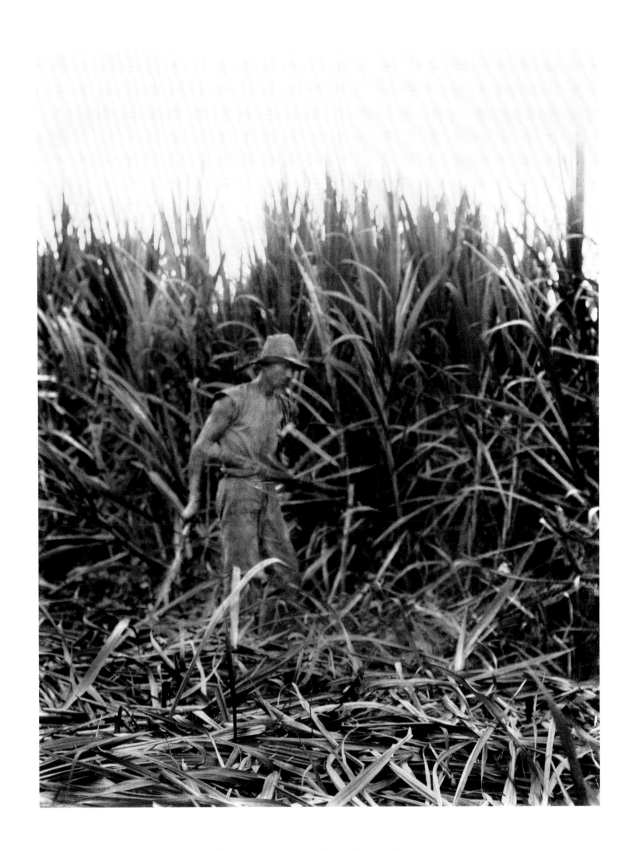

Harvesting sugar cane, Cairns, Queensland, 1930

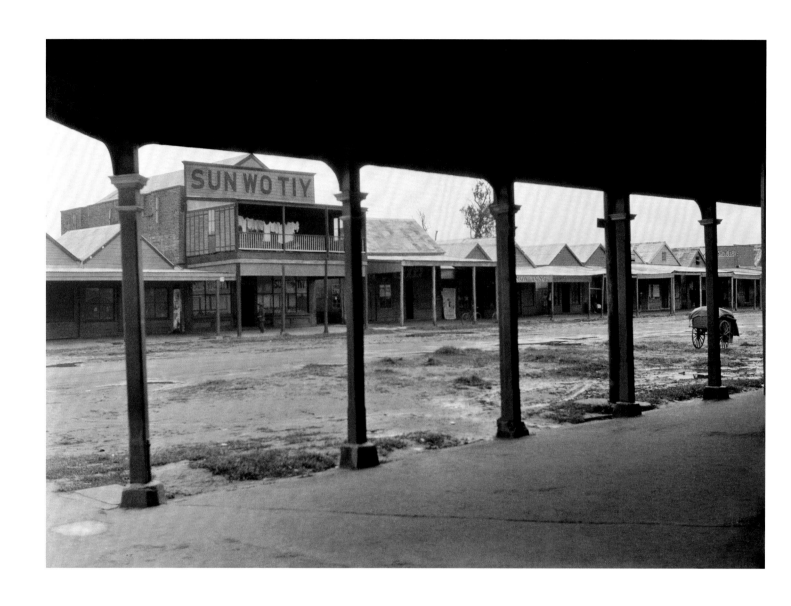

Chinatown, Darwin, Northern Territory, 1930

Chinese graves, Thursday Island, Northern Territory, 1930

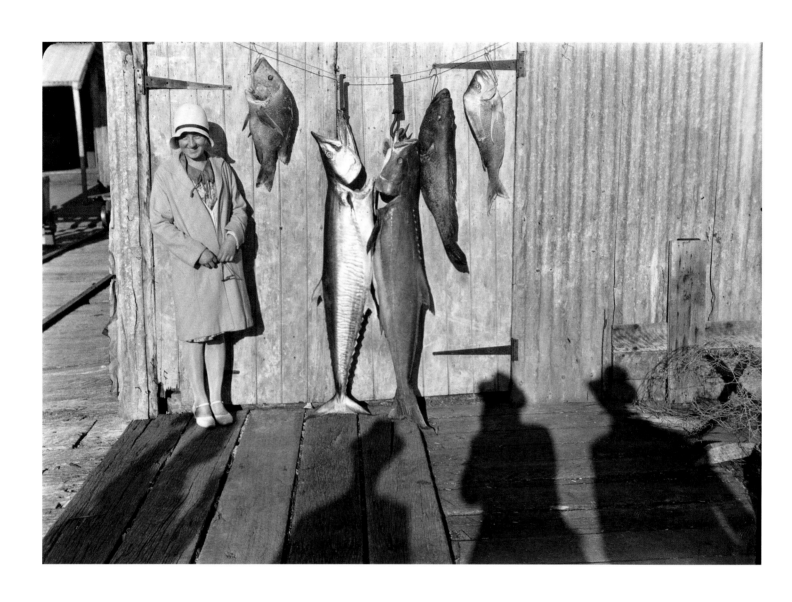

Gladstone, Queensland, 1930

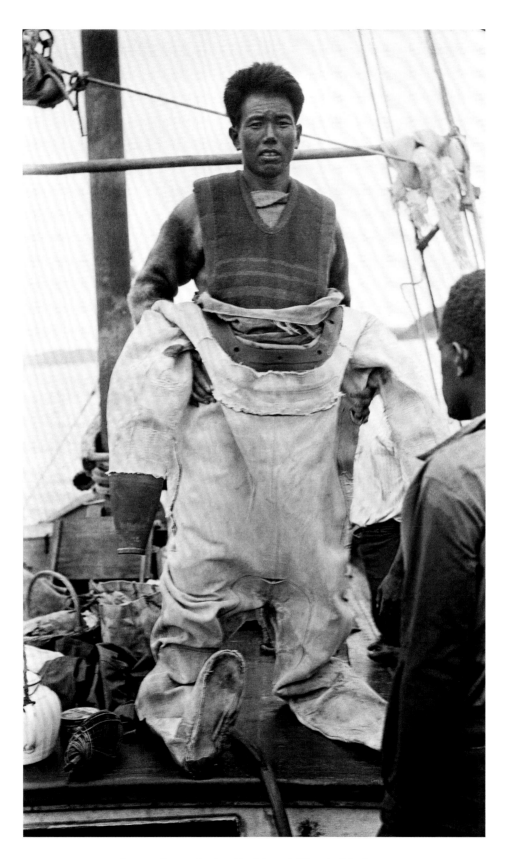

Japanese diver getting into his diving suit, Thursday Island, 1930

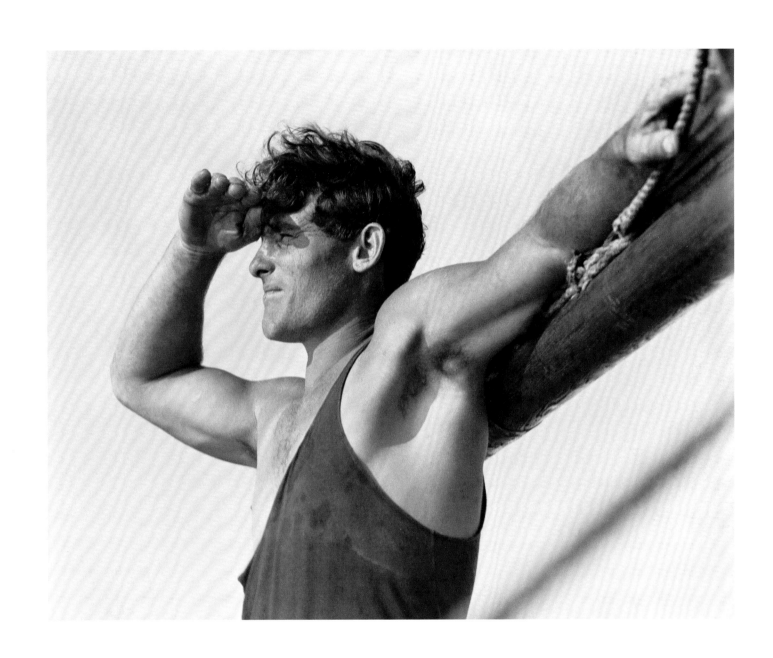

Pearling look-out man, Thursday Island, 1930

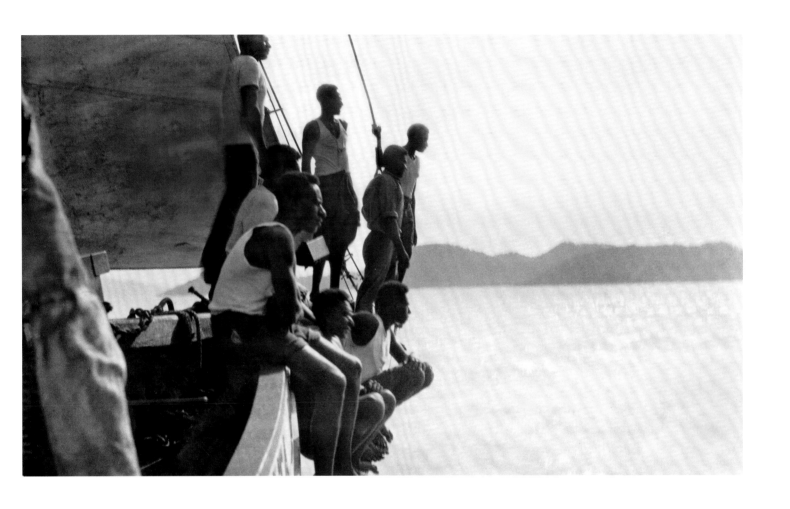

Pearling, Thursday Island, 1930

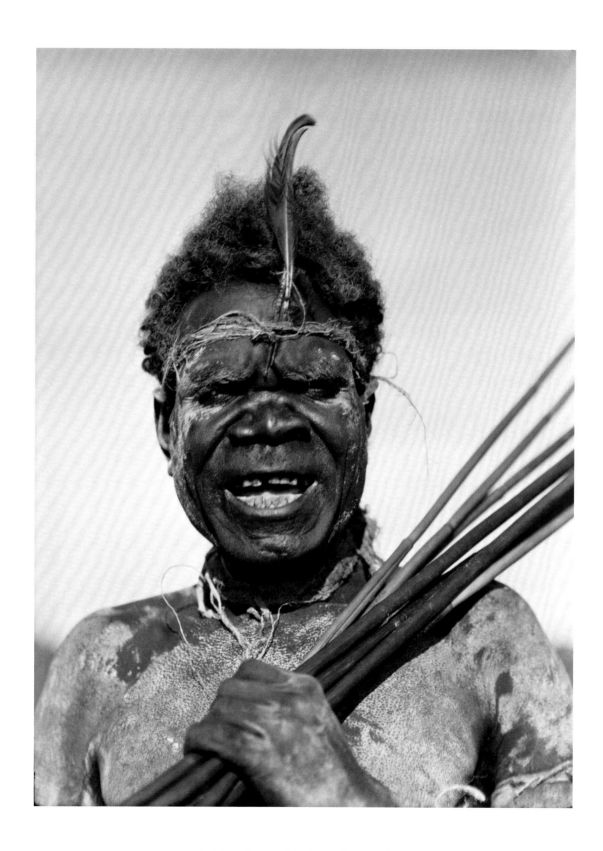

Aboriginal tribesman, Palm Island, Queensland, 1930

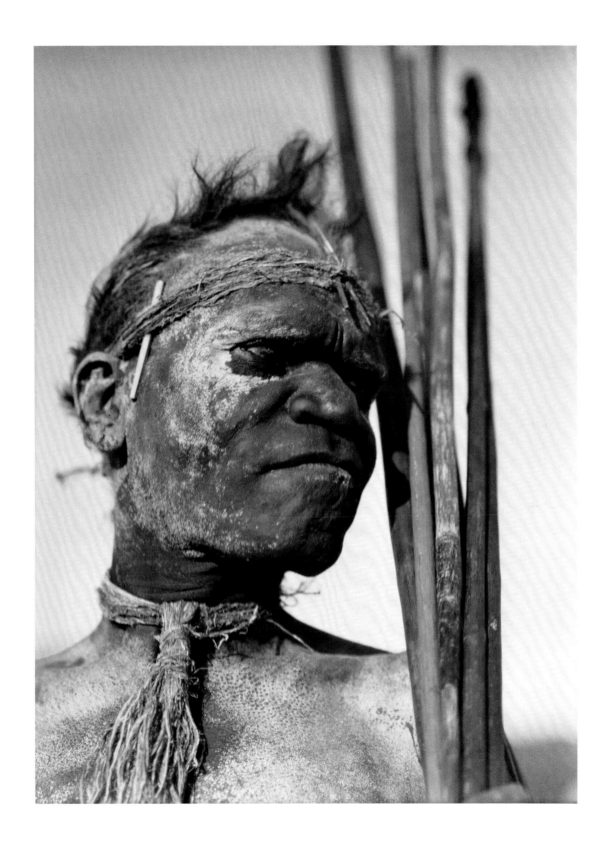

Aboriginal tribesman, Palm Island, Queensland, 1930

Yarra trees, Western Australia, 1930

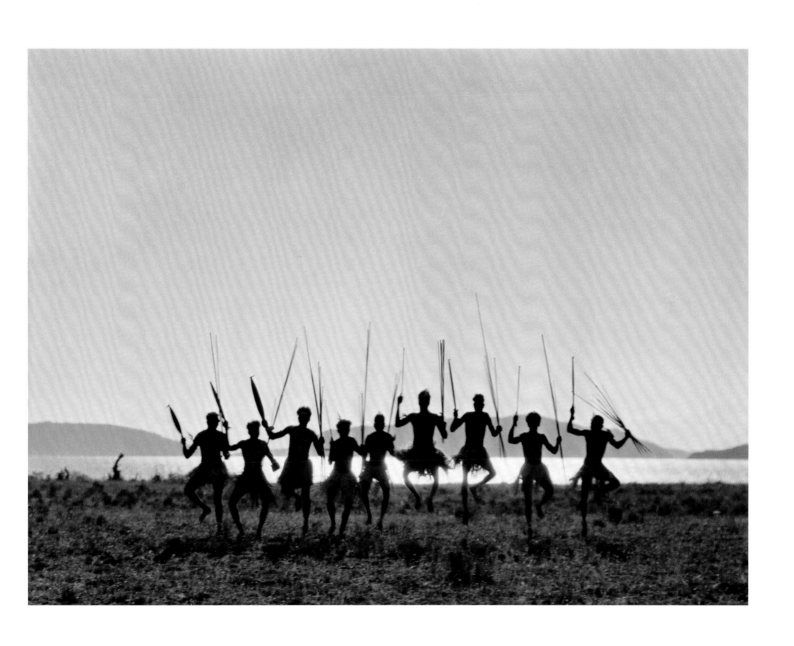

Incident in play, Aboriginal war dance, Palm Island, Queensland, 1930

ACKNOWLEDGMENTS

We are deeply indebted to Gael Newton, senior curator of Australian Photography, the Australian National Gallery, Canberra, for her expert knowledge on the history of Australian photography and generous help enabling this trans-Pacific effort to come to fruition. We are also grateful to Phillip Prodger and Claudia Sorsby for editing various drafts of this essay. Thanks to John Drury and Richard Lubner for inspiration with this effort. Thanks to Pam Moffat for research help in the Hoppé Archive and to Philipp Scholz Rittermann, Alex Mendoza, and Paul Costigan for their expertise in providing superb digital files for this book. Thanks go to John Drury and Richard Lubner for their inspiration and help in the realisation of this project and to Judy Annear, Linda Groom, Mark Haworth-Booth, and Peta Hill whose support has been unfailing. —G.H. & E.E.

NOTES

1. E. O. Hoppé, *The Fifth Continent*, London: Simpkin Marshall, 1931, p. vii.

2. E. O. Hoppé, unpublished manuscript, autobiographical notes, p. 2, Hoppé Archives, Curatorial Assistance, Pasadena, California.

3. A group of photographers active between 1892 and 1909 formed The Linked Ring to further photography.

4. E. O. Hoppé, *One Hundred Thousand Exposures: The Success of a Photographer*, The Focal Press, London, 1946.

5. *Photo-era*, vol. 17, no. 2 (Aug. 1906), pp. 78.

6. 'Individuality in Portrait-Photography', *The Australasian Photo-Review*, February 23, 1914, pp. 68–70.

7. Cecil Beaton's introduction to: *E. O. Hoppé, One Hundred Thousand Exposures: The Success of a Photographer*, The Focal Press, London, 1946.

8. Phillip Prodger, *E. O. Hoppé's Amerika: Modernist Photographs from the 1920s*, London and New York: W.W. Norton, 2007, p. 5.

9. We thank Dr. Roland Jaeger, Hamburg, for the information about the Orbis Terrarum series and Martin Hürlimann's Atlantis-Verlag. Conversation with Erika Esau, 20 February 2007.

10. *One Hundred Thousand Exposures*, p. 154.

11. Op. cit., p. 161.

12. For a brief description of the significance of the graphic design of *Deutsche Arbeit*, see Jürgen Holstein, ed. Blickfang: Bucheinbände und Schutzumschläge Berliner Verlage 1919–1933, Berlin: Holstein, 2005, p. 366, 367.

13. Hoppé's 1916 exhibit at London's Goupil gallery exhibition included approximately twelve works that are today considered modernist abstraction.

14. 'Noted Traveller, Mr. Hoppé's Visit', Friday March 28, 1930, *Sydney Morning Herald*.

15. 'A notable one-man show', *The Australasian Photo-Review*, 15 May, 1930, p. 225.

16. *Australasian Photo-Review*, 15 May, 1930, p. 226.

17. Ibid.

18. *The Australian Budget*, 11 April 1930, p. 11.

19. Gael Newton, *Shades of Light: Photography and Australia 1839–1988*, Melbourne and Canberra, Collins, Australia and National Gallery of Australia, 1988, p. 107.

20. Gael Newton, 'Fame, Fortune and the Fifth Continent', *World of Art and Antiques*, February–August 2007, pp. 14–17.

21. *The Second Bridge Book*, Art in Australia Ltd., 1931.

22. In e-mail correspondence with Erika Esau, 7 January 2007.

23. E-mail to Graham Howe from Lisa Moore, David Moore Archive, Sydney, 7 September 2004.

24. Information on Atlantis-Verlag contracts from Roland Jaeger, in conversation with Erika Esau, 20 February 2007.

25. *One Hundred Thousand Exposures*, p. 190.

26. *One Hundred Thousand Exposures*, p. 196.

27. Mario Einaudi, curator of the Kemble Maritime Ephemera Collection, Huntington Library, San Marino, California: In the 1920s, the *Otranto* had departures from London to Ceylon in mid-July and in mid-September.

28. *Argus*, 27 January, 1930, p. 5. *The Melbourne Herald*, 27 January, 1930.

29. *One Hundred Thousand Exposures*, p. 196.

30. 'World Wanderer/Famed Photographer Tours/ Marvellous Milford Sound', *The Sun* (Auckland), 21 March, 1930, p. 10.

31. *The Australian Budget*, 11 April 1930, p. 11.

32. 'What IS Photography?—E.O. Hoppé to tell', The Australian Broadcasting Company, Sydney, typescript, no. 1262, Hoppé Archive, Curatorial Assistance, Pasadena, California.

33. Hoppé and his son had a 'frightful row'—Frank felt that he was being used as a pack animal, and refused to continue. When Hoppé threatened to leave him in Australia if he would not continue as his assistant, Frank said he would be delighted to stay. The offices of Charles Lloyd-Jones secured Frank a menial post at the David Jones store, where Frank stayed for nearly two years. He eventually moved into the company's advertising department, where he learned the trade that he would continue to practice for the rest of his life. He finally left Australia when his mother prevailed upon him to return to England. From interview with Frank Hoppé, by Graham Howe, 8 November 1994.

34. Gladys Hain, 'E.O. Hoppé, World Traveller and Artist', *Illustrated Tasmanian Mail*, 14 May 1930, p. 10.

35. Ibid.

36. Hoppé published several versions of the story of Minnie Barrington, the only woman amongst the opal miners. See for example 'The Romance of the Opal Fields', *The B.P. Magazine*, March 1, 1932, pp. 41–42.

37. 'Never until these later years of my travels have I come to think of a wood as "timber." . . . Trees are meant to live their stately life in undisturbed tranquillity, to grow old gracefully, and at last when they are decayed and tired, to fall and die. That they should be lopped, cut and hacked, should become in fact timber, to serve the purpose of man, seemed to my romanticism a terrible and cruel thing. It was my visit to Bunbury, which brought these thoughts again into my mind. Here quite definitely a wood was "timber" and nothing else'. Hoppé, typescript autobiography, p. 71.

38. 'Terra Australis/Author in Cairns/Exploring a Continent', *Cairns Post*, July 22, 1930.

39. 'Central Australia/Mr. E. O. Hoppé's Tour/From Adelaide to Darwin', *Sydney Morning Herald*, 15 September 1930.

40. See for example 'Toiletten-Geheimnisse im australiaschen Busch,' *Berliner Illustrirte Zeitung*, no. 10, p. 397.

41. 'Famous Writer Here/A Distinguished Visitor inspects Innisfail', *Johnstone River Advocate*, 29 July 1930, p. 1.

42. Ibid.

43. E. O. Hoppé, 'Australian Capitals', *Canadian Geographical*, March 1952.

44. Conversation with Erika Esau, 20 February 2007.

45 'Review: The Fifth Continent. By E. O. Hoppé . . . We Find Australia by Charles H. Holmes . . .' *The Geographical Journal* (England), vol. 82, no. 1 (July 1933): pp. 83–84.

46 Ibid.

47. Ibid.

48. *The Australians*, Adelaide: Rigby, 1966.

49. We are grateful to Martyn Jolly for sending this section of his M.A. thesis, 'The Perpendicular and the Oblique', University of Technology, Sydney, Australia, 1994, p. 83.

50. From summary text at the Australian War Memorial website, http://cas.awm.gov.au/ Accessed 16 February 2007.

51. Anne-Marie Willis, *Picturing Australia*, North Ryde, NSW: Angus & Robertson, 1988, pp. 177–179.

52. *Shades of Light*, p. 107.

53. *Geographical Journal*, p. 83.

54. *Fifth Continent*, p. ix.

55. Prodger, p. 8.

56. The first great anthropologist to photograph extensively among the Aborigines was Baldwin Spencer (1860–1929). A new edition of his visual work has appeared, *The Photographs of Baldwin Spencer*, ed. Philip Batty, et al. Melbourne: The Miegunyah Press, 2005.

57. Hoppé, 'Hermannsburg, eine deutsche Mission im Innern Australiens', *Atlantis*, vol. IV, nr. 3 (1931): pp. 241–252.

58. The authors are grateful to Nicolas Peterson, professor of Anthropology, School of Archaeology and Anthropology, The Australian National University, for his advice about the appropriate display of Hoppé's Aboriginal images. E-mail correspondence, 20 January 2007.

59. Rick Smolan, ed. *A Day in the Life of Australia: Photographed by 100 of the World's Leading Photojournalists on One Day*, New York: Collins, 1988.

60. Leonard McCombe, 'Career Girl: Her Life and Problems', *Life*, 3 May 1948.

61. *Fifth Continent*, p. xxxii.

Italicized page references refer to plates and figures.